Dtp and graphic design

Iacob Adrian

Copyright©2012-2014 Iacob Adrian
All Rights Reserved.

Author statement

The actors and actresses are the the bricks .

The cast and crew are the plaster .

They stand on the foundation created by producers and writers and directors .

All these people creates the great palace of the art of film .

Iacob Adrian - 2013

This little Book conveys the greetings of

..

to

..

————————————————

I'M A GAY

—Eugene Robert Richee
Divorce, with its freedom and independence, is a swell idea, says Carole Lombard, but it never works out!

—Russell Ball
Carole Lombard misses now the protection William Powell gave her as her husband

It has been a little over a year now that I ceased being Mrs. William Powell and became Carole Lombard again.

In other words, for about thirteen months I have been supposedly as "free," "gay," and as "carefree" as only a Hollywood divorcée is cracked up to be. I have repeatedly stated I do not believe the average professional marriage in Hollywood can be a success. I haven't changed my mind. I still think Bill and I are better friends now because of our separation than we would have been in spite of our marriage. With our temperamental differences divorce was the only logical step for us. But speaking from months of experience I am not at all convinced that the life of a Hollywood divorcée is all it is publicized to be!

Women are funny creatures. Movie stars are even funnier. I suppose there is really no perfect state for a woman with a Hollywood career. Perhaps that is the reason why so many women stars try marriage . . . and finding it fails, try divorce . . . and finding *that* fails, try marriage again . . . and so on through several marital interludes. Speaking for myself, I have not reached the point where I would even consider another flyer into matrimony . . . but I am going to be very frank:

There are many delightful moments of companionship and sociability and good old-fashioned protection that I miss from marriage. And there are many supposedly exciting moments from my short life as a divorcée which I find boring and annoying.

● I suppose the fans have decided from the number of divorces in Hollywood, and the gala way they are conducted, that the legally free movie star tosses her hat in the air the minute her lawyer puts her interlocutory decree in her hands and says (at least, inwardly): "I am free! My life is my own again. I can come and go as I please . . ."

It is a swell idea if it would work. It doesn't!

The truth is, I had more actual freedom from gossip, from gossip writers and from kindly meaning friends when Bill and I were married than I have enjoyed for one moment as Carole Lombard ex-Powell. When I was married I frequently dined with friends when Bill was working nights at the studio, and perhaps there would be an extra man along. No one thought much about it. But let me dine now with the same friends and an unattached male in the party, and the next day I am surprised (and no doubt he is, too) to read we are the newest Hollywood love affair!

As Mrs. William Powell I could send an innocent wire of

HOLLYWOOD

DIVORCÉE

by Carole Lombard

as told to **DOROTHY MANNERS**

heh - heh

And Carole says it with a hollow laugh, for a Hollywood divorcée is far from happy!

OH BOY — A DIVORCÉE EH!

congratulation on a new contract, or an excellent stage or radio appearance to some actor I knew, and no notice was taken of it. The same message coming from Carole Lombard, divorcée, is described as "showering wires" upon the latest sensation of the screen, stage or radio! This sort of thing can become so embarrassing that I find I am going out in public less and less frequently.

There have been nights when I have actually *wanted* to go to the Cocoanut Grove, or one of the other dancing spots with some casual friend, and yet I have hesitated to do so because I knew we would be met by a battery of news cameramen all set up to shoot the "evidence" of our flaming love affair!

Last week I wanted to go to the mountains on a short rest vacation. I couldn't. One of my rumor-romances was vacationing there. So, instead, I went to the beach (and I'm heartily sick of it!) If this be freedom . . . make the most of it!

● And then there are your friends . . . not your intimate friends of course, they always understand . . . but that vast army of friendly acquaintances who insist upon "cheering you up!" I have discovered that as a married woman I was not nearly so

Please turn to page sixty-one

SEPTEMBER, 1934

Men treat a divorcée differently than they do a single girl, Carole Lombard has found

I'm a Gay Divorcee

much at their mercy as I am as a divorcée. If Bill and I were invited to a party, and for some reason or other we could not attend, all we had to do was to send regrets. But regrets from a newly unattached girl? Don't be silly! "You must come, my dear. I can't bear to think of you being alone . . ."

Or take the other angle of this entertaining problem. When Bill and I were married we entertained frequently. And because he is such a splendid and natural host only the pleasant duties fell my way, such as arranging the flowers and seating the guests. Everything went so smoothly I was often a guest at my own parties.

But when the divorcée entertains in her brand new bachelor quarters . . . ah! There is entertainment!

Everything from calling up the caterers to paying off the stringed orchestra falls to her, not to mention that little detail of seeing that So-In-So doesn't fall asleep in a corner undiscovered until daybreak when he is always spotted by a neighbor taking a solitary departure (*scandal!!!*).

In the year and a half of our married life, Bill and I gave many parties, as I have mentioned before. We never had one disagreeable moment through jealousy! My charming ex-husband had implicit confidence in me, and if I was seen carrying on a tête-à-tête with a handsome guest . . . he regarded it merely as one of the duties of a good hostess. I can't say this same attitude is true of several gentlemen whom I know quite casually since my divorce! It can be quite annoying to find yourself explaining your actions to a more or less furious young man who has not the slightest claim to explanations . . . or anything else.

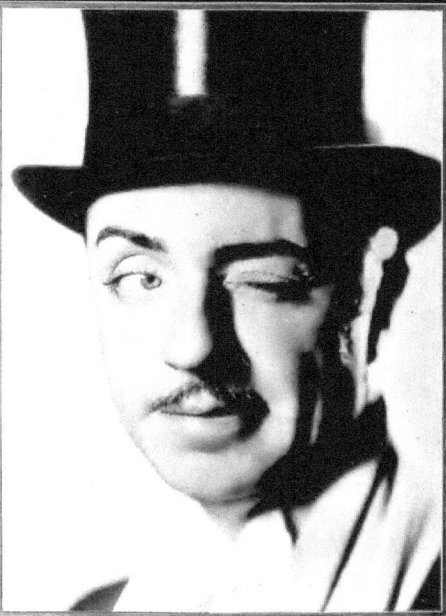

Men! New Men! A perfect passing parade of men . . . these are supposed to be the highlights of interest in a divorcée's life. And at first (I insist upon being truthful about all this) the ringing of the telephone, and the sound of a nice, masculine voice asking for a dinner or dancing engagement, is nice . . . and, often, exciting. You think: "This reminds me of my flapperhood . . . of those gay days and nights when I was free, white and unattached with a string of beaux to take me out every night in the week." I say, you think this, at first! And then you begin to wonder about many things:

We never go backward in life. All of us, except the nit-wits, must go forward. If we lose, or escape giddiness . . . we seldom recapture it . . . which is just as well. If we have found one man to whom we can talk and enjoy the quiet moments, we are that much wiser about men with whom we can only dance and dine and pass the frivolous moments of life. Every girl goes through the period when any attractive man who dances well and makes a presentable appearance is a suitable escort for an evening. And every divorcée reaches the stage where she knows better! Another thing:

When a girl is single, before she has ever been married, every new man she meets carries the promise of possible romance to her . . . and she to him. Their association is sweet because the men she meets are usually younger and less experienced. But the divorcée finds these boy-and-girl romances closed to her forever . . . because, well, just because they are! The suitors at the divorcée's court are of a far more worldly stripe.

I was surprised one evening to be called to the telephone by a man in Hollywood who enjoys a thoroughly hectic reputation as a rounder and playboy. I had met him casually at a big party the evening before.

"Hello, Carole," he hailed me. "How about getting into your glad rags and going stepping?"

I replied, "Sorry, but I'm very tired." I had no intention of being seen with this man.

"Don't be silly," he insisted, "I'll be right over for you. We'll raise some whoopee!"

I tried to put him off. "I have another engagement."

"Break it," he commanded. "I'll be over in ten minutes."

I was thoroughly angry by then. "I won't be here," I screamed into the 'phone . . . but he didn't hear. He was already on his way.

One of the truths about being a Hollywood divorcée is that it can be most annoying to have to turn out all the lights in your house, "sushhhh" your servants and sit in the dark for a half-hour or so, while playing "not at home" . . . to such unwelcome cavaliers as this gentleman!

Why hedge . . . or muddle the point? Men have an entirely different set of social philosophies toward a girl who is merely single and one who has recently been freed by law! And every divorcée knows what the difference is!

If I were to try to sum up what hangs in the balance between the benefits and failings of being a Hollywood wife . . . and the blessings and annoyances of being a Hollywood divorcée . . . I could only repeat what I said earlier in this article . . . *there's no such thing as a perfect state for a woman with a Hollywood career!* For the great god Studio is the most jealous lover of them all!

SEPTEMBER, 1934

BILL POWELL TAKES OFF HIS MASK

by J. EUGENE CHRISMAN

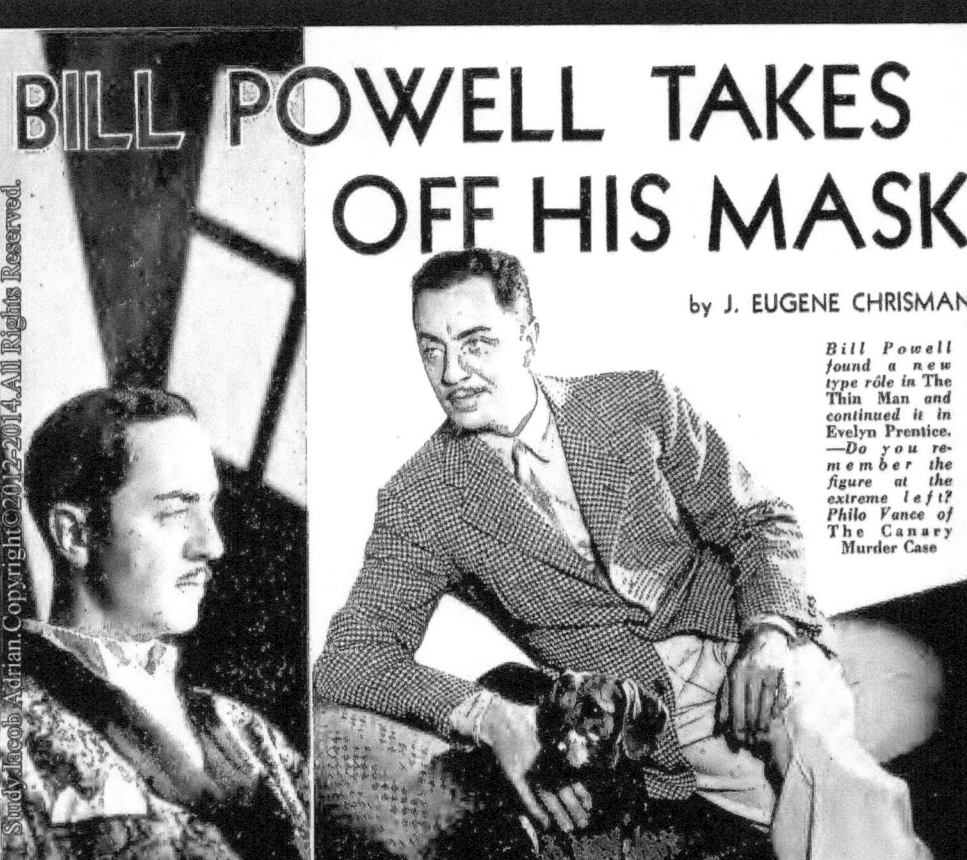

Bill Powell found a new type rôle in The Thin Man and continued it in Evelyn Prentice. —Do you remember the figure at the extreme left? Philo Vance of The Canary Murder Case

There's no new Bill Powell ... The villain of silent films, and the sophisticate of early talkies finds a new rôle but he can't fool his friends ... They know Bill is just being himself

HOLLYWOOD IS NEVER content to let well enough alone. It is a community of constant change, the most chameleonic city in the world. Off with the old and on with the new, is their slogan.

Out here people go to the divorce courts to change wives and husbands. Plastic surgeons alter the appearance of their faces. The expert hair dressers make over their coiffures. Dieticians and massage masters change their figures. Publicity departments change their personalities.

Thus it is that we are always reading of *The New Joan Crawford*, every time Joan changes the style of her hairdress. *The New Clark Gable* is heralded on each variation of screen character. Elissa Landi decided to soft pedal the pure and innocent rôles and become a wicked woman and the publicity departments listed her as *The New Elissa Landi*.

When William (the fellows call him Bill) Powell first smashed through with one of the screen's grandest performances in *The Thin Man*, a type of rôle in which the public had never seen him before, he was also hailed as *The New William Powell*. But he wasn't changed. He was just being himself and for the first time since he began his picture career. The public, who had seen him only as a sneering *heavy* in the old silent days and as the suave, polished, sophisticate since the talkies, wondered what had happened to Bill but his friends, who were in on the secret all the while, only chuckled. They knew that Bill Powell had always been the sort of a guy who would toss a raw egg into an electric fan just to see what would happen. Scores of them knew that, while in public Bill is a runner-up for the title of Hollywood's best dressed man, he loves to run around his house in the raw. They know that he prefers a tattered old sweater and a pair of disreputable slacks to a tail coat and that when he does wear tails, they are usually completely wrecked by the time the party is over, if Bill is being himself.

● They remembered the Bill who plays *Philo Vance* in the privacy of his own home, entirely without an audience and the time when, having concluded that opening a door lock with a hairpin was a simple trick for a detective, he locked himself in his own bathroom, armed only with a hairpin, (we don't know where he acquired it), and threw the key out the window. But it wasn't so simple as he had expected and he escaped by climbing down the drain pipe.

They recalled the recent boating trip he took with his pals, Dick Barthelmess, Ronald Colman and Warner Baxter into Mexican waters. This was the Bill who

Bill Powell Takes Off His Mask

appointed Barthelmess *Admiral*, Colman *Captain*, himself *mate*, and Baxter, who is no sailor, *passenger*, and kept the entire cruise in a hilarious state.

They remembered the Bill Powell who loved to squirt water from charged siphons on to stiff shirt bosoms and who will be doing a gay fandango with a sedate matron one minute and offering an expert critique on a rare etching the next.

Too many of them have been caught by the stock of trick toys which Bill keeps in his home for the downfall of unwary guests to not remember that boyish side of the man.

I heard about this new William Powell and went to see Bill himself about it. I found him listening to the dulcet strains of the hidden pipe organ in his living room.

"Yes," he smiled and spoke in that crisp, clean-cut manner of his, "I suppose you are right. *The Thin Man* gave me my first opportunity to be myself on the screen. No, I haven't any complaint about the rôles I played before. Why should I? I didn't like *Philo Vance* any too well but he made a mint of money for the studio which produced him and he did well by yours truly also. I suppose I actually became *Philo* to the public but I never did to my pals. I did get tired of being referred to in print as the suave, polished sophisticate but what does that matter? In the silents I played villains. When the talkies came along, my voice seemed to fit the more polished, sophisticated rôles, since I had been trained on the stage. That's how it all began."

But Bill is convinced that life, for him, is beginning at forty. He feels that Metro, to whom he is now under contract, will give him a wider opportunity to display his versatility. He doesn't much care what it is, just so it gives him an opportunity to turn in a creditable performance.

"I have no illusions," he insisted, tossing restlessly on the couch where he was sprawled, "I know I'm no Gable or Valentino. I'm just a fellow who wants to get along in the work he loves. Give me rôles in which I get a fair chance to show up well and let the rest of it go by the board."

Another ambition of Bill's is about to be fulfilled. All his life he has wanted a certain kind of house, a house he could call his own. Now, at last, he is about to have it. He has purchased the old Hobart Bosworth home on Beverly Boulevard, next door to that of Cord, the automobile manufacturer. He is having it done over, entirely according to his own tastes and almost by the time this is in print, he will have moved in.

Just As Bill Powell can never be anything but the little boy who failed to grow up, neither could he have been anything but an actor. Acting is to him as natural as breathing and as unconscious. He can balance a tea cup with sub-debs and eat mulligan out of a tin can in a hobo jungle with equal ease. When you watch him shave, you realize that it is a game and not a drudgery as with most men. He constantly experiments with new ways to get the whiskers off and sometimes you fear he is about to cut his own throat but it has not yet happened at this writing.

He enjoys parties, but likes sleeping best of all and sleeps in a bed big enough for twin *Man Mountain* Deans. He is facile, adaptable, and an excellent conversationalist. He has never been known to lose his poise, even when appearing at a party dressed in tails where the other male guests wore dinner jackets or street clothes. He can, when he wants to, assume a haughty air but it is always in fun. You never know what Bill Powell will do next and after you know him well enough, you don't care. Whatever it is will be either clever or entertaining.

So Don't let anyone kid you about there being a *New Bill Powell*. There isn't any such animal. The Bill Powell you saw in *The Thin Man*, is the same Bill Powell Hollywood has known for years. He has just decided to let the public in on the secret. You're going to see him in a sequel to it in the near future and Bill told me some of the sequences already written but since he asked that they be *off the record*, I can't tell.

Bill Powell has hit his real stride. You have watched him through the black mustached, villainous period and the stuffed shirt era. Watch and see what he does now that he is permitted to be himself.

Drop me a line

HOLLYWOOD offers dollars for your movie thoughts! Money for letters to stars! Read the rules on page 57

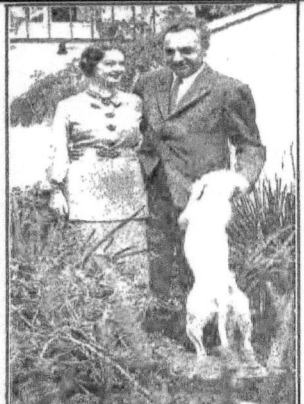

—Photo by Rhodes, HOLLYWOOD Staff Photographer
With Evelyn Venable and her cameraman-husband, Hal Mohr—seen in the garden of their honeymoon home—it was a case of love at first sight, and love tested for a year

The "confession" in William Powell's answer to Mrs. Ste. Fleure's letter qualifies as a Strange Movie Fact. He hasn't seen all of his own pictures!

A Tribute to Be Treasured
$10.00 Letter

Dear Mr. William Powell:
I am no movie fan, being an old lady, seventy-one years of age; but I have great pleasure in expressing my sincere admiration of your fine acting. You are so natural, and well poised in any part. And this was true of you even when you made the silent pictures.

Of course, *The Thin Man* gave you a fine opportunity of showing how very well you can act.

I never miss any of your pictures, and hope that you will long continue your splendid career.

Sincerely yours,
MRS. MARION STE. FLEURE,
P. O. Box 268,
Santa Barbara, Calif.

To "A Lady of Charm"
$10.00 Letter

Dear Miss Dunne:
A few years ago Conrad Nagel introduced you on a broadcast as "A Lady of Charm, Miss Irene Dunne." The heavenly song you rendered at that time remains with me as a treasured memory.

Since then, you have always been, my "Lady of Charm." It is not idle flattery, when I say that beauty, charm and intelligence such as yours are a rare combination.

I would not take anything in the world, for my memory of you, in *Cimarron, Back Street, Stingaree* and many other lovely pictures. All the romance in me lives again, and I am oblivious to all around me. I love you for just that, and the soul in your song.

Sincerely,
GERTRUDE CROWTHER,
1925 N. E. 25th Avenue,
Portland, Oregon.

(Editorial aside to Reader Crowther and all other admirers of the Dunne charm: We hope you didn't miss "What I Have Learned About Glamour" by Irene Dunne in April HOLLYWOOD*! On Page 34 of this issue, you will find a review of Roberta, in which Irene's charm, glamour and singing all have full play.)*

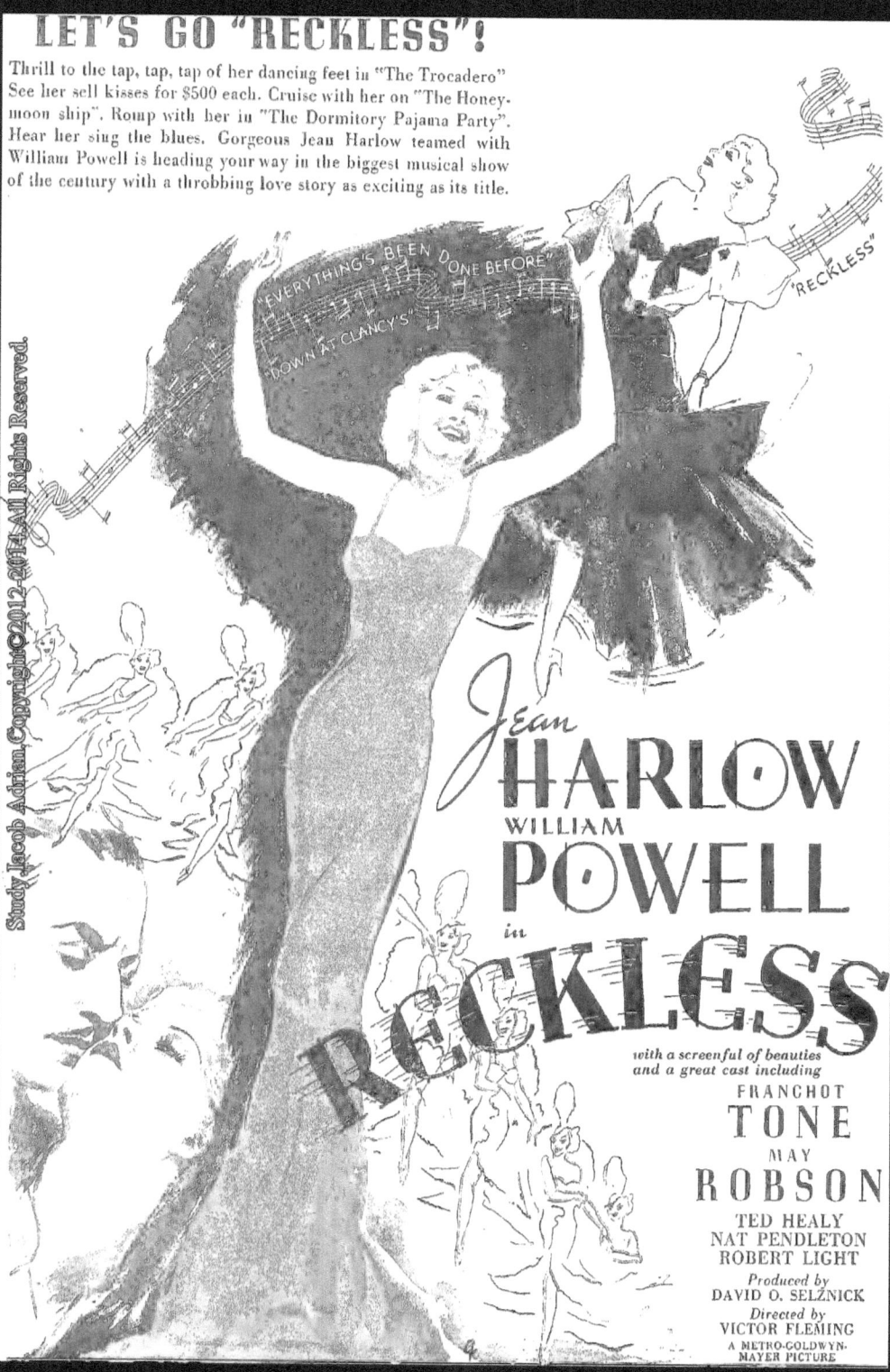

Discovered

IN A HOLLYWOOD PROJECTION ROOM!

Together, A GREAT STAR and a NEW STAR

The hush in the Metro-Goldwyn-Mayer projection room turned to a muffled whisper... the whisper rose to an audible hum... and in less than five minutes everybody in the room knew that a great new star had been born — LUISE RAINER — making her first American appearance in "Escapade", WILLIAM POWELL'S great new starring hit! It was a historic day for Hollywood, reminiscent of the first appearance of Garbo — another of those rare occasions when a great motion picture catapults a player to stardom.

WILLIAM POWELL in *Escapade*

with LUISE RAINER
FRANK MORGAN
VIRGINIA BRUCE
REGINALD OWEN
MADY CHRISTIANS

A Robert Z. Leonard Production
Produced by Bernard H. Hyman
A Metro-Goldwyn-Mayer Picture

William Powell adds another suave characterization to his long list of successes... and Metro-Goldwyn-Mayer swells the longest list of stars in filmdom with another brilliant name — Luise Rainer!

Aristocrat, sophisticate, innocent — one wanted romance, the other wanted excitement — but one wanted his heart — and won it!... Sparkling romance of an artist who dabbled with love as he dabbled with paints... and of a girl who hid behind a mask — but could not hide her heart from the man she loved!

WILLIAM POWELL'S
Sure Cure for Colds

Here's one way to end a cold—
we recommend you don't try it!

by HARRY LANG

THIS IS A screwy story about How To Cure a Cold the Way Bill Powell Does It. If you like your reading sane and sensible, then skip this one, because it's plain nuts. . . .

Now, about this cold of Bill's. He didn't know he was curing it. Didn't I tell you this story was crazy? As a matter of fact, you can't appreciate just HOW nutty it is until I warn you that it begins with the late Florenz Ziegfeld and chocolate creams, and before it ends, it's all tangled up with rain, ice cream, a beautiful blonde star, Bill's automobile and a lot of other irrelevant and immaterial things, and the balmiest series of misadventures that ever befell anybody—even Bill Powell.

Of course, if you think you can take it, read on—

It seems that what started all this was the fact that M-G-M learned that Florenz Ziegfeld used to munch chocolates continually. So, when they cast Bill Powell as the great glorifier in *The Great Ziegfeld*, the first thing the prop department got was lots of chocolate candy, and started Bill gnawing them.

Right away, life began to brighten for Bill. If there's anything he particularly likes, it's chocolate candy. And then, Art is Art and Anything for It, is Bill's motto, so down went the chocolates, with Bill saying pretty things about each piece.

BUT!—chocolates add up to acidosis, and before he knew it, poor Bill was as full of acid as a mother-in-law. Acidosis, in turn, makes even a movie star's system highly receptive to the common cold germs, and whoo-WHISH—came a draught, and Bill had a cold.

● HOME TO BED he went, and that was swell. For not even his best friends point to Bill as an example of industry and energy. Bill himself modestly admits that laziness is one of his greatest virtues. For two days, he had a fine time, because he was in bed. Life and the world wasn't such a bad place after all—until . . .

"Br-r-r-r-rING!" went the phone by Bill's bedside, and when Bill answered, darned if it wasn't the studio.

"Hello, Bill?" came the voice.

"Uh, huh, I'm dying; lemmealone," said Bill.

"We're shooting the big Mardi Gras scene tonight, and you're needed."

Bill looked at the clock. It was six o'clock. P. M!

"This," said Bill, "is a so-and-so hour to ask a man to get out of his deathbed and go to work." But because Art-is-Art-and-My-All-For-It is good old Bill's motto, he got up and put on his Ziegfeld clothes. And he went down to his garage and told Providence all about the injustice of studios and life in general, and climbed into his new flivver which had the top down, and started for the studio. . . .

Above, Bill Powell sips a concoction for colds and sighs profusely. Below, he's shown with beautiful Jean Harlow

FEBRUARY, 1936

William Powell's Sure Cure for Colds

● HALF-WAY THERE, the gates of heaven opened. That's poetical, but what happened when they oped wasn't. All the rain California had been storing up during its lovely (adv't.) summer came down in one piece, and about 99 per cent of it landed right on the middle of Bill's neck.

Bill stopped his car and called things names. The world, obviously and damnably, was agin' him! He began to put up the top on his car, and the top stuck...!!!

Bill pulled valiantly. The top stuck even more valiantly. Bill imbued it with personality, because thereby he could make remarks about its mother, indirectly speaking, but still it stuck. Bill gave a mighty yank, and it squirted some accumulated rain down his shirt. That was too much. Bill got up on the seat and with all his strength, he yanked at the dam' thing until it came up — and OFF ...!!! He had smashed it beyond up-putting.

"All right," he wept, in rage; "if that's the way you feel about it, then..." —and without more ado, he put his foot neatly and decisively through the windshield. "I'll show you!" Then he sat down in the two inches of water that had gathered on the seat, and soliloquized on the horrors of life. He finally reduced it all to a simple "Nerts!" and drove on to the studio, the rain splashing blithely and merrily on him.

● BUT OLD LADY FATE, the quaint old prankstress, had just begun to play. At the studio, she pulled a trick. Just as Bill drew up, drenched, an assistant director hailed him:

"Oh, never mind, Bill—we've just decided not to shoot that scene tonight. We won't need you."

At this point, gentle reader, we delete. We skip. We pass over. We close our ears and our minds to the details of what Bill said about movies, assistant directors, automobiles, rain, and other things. If you must—and can—you may imagine it for yourself. For our part, we refrain. And we take up the narrative again at the point where Bill sits in his rain-soaked car, on his rain-soaked seat, and in his rain-soaked mind, decides he wants a friendly shoulder to cry on.

"Why not so-and-so's?" he asked himself, naming an actress-pal you all know. She would understand! She would be sorry for him! So he called up so-and-so's house.

"Hello, Bill," she helloed.
"What," he asked, "are you doing?"
"I'm dying!—with a cold," she told him.

The world reeled about Bill's consciousness. Was this all a gag?

"Did you say—cold?" he asked.
"Yes, Bill. What are YOU doing?"
"Well—I've got a cold, too," he remarked.
"What are you doing for it?" she wanted to know.
"Oh—just driving around in the rain," he told her.
"Are you crazy?" she asked.
"I think so," he admitted. "You like ice cream?"
"Yes," she conceded.
"Fine. I'll bring up some vanilla and some chocolate, and we'll eat it and have our colds together, eh?" he asked.
"All right, come ahead," she said.

With the ice cream, Bill drove through the rain to so-and-so's hillside home. He didn't mind the rain any more. He couldn't get any wetter, and he was sure he'd die of pneumonia tomorrow, so what the—? He reached the gates to so-and-so's fence, and stopped.

All was dark. He tooted. Nothing happened. He asked God to do something about it, in monosyllabic pointedness. Whether or not God did, still nothing happened. Bill banged on the gates, he yelled, he tooted his horn, he raced his engine. Still nothing happened.

So finally, realizing the servants had not been told to open the way for him, he gave up.

This was the last straw. Too much was too much. The world was completely, utterly, awfully agin' him. A man could fight assistant directors and recalcitrant auto tops and ice-cream clerks and things like that, but he couldn't take on all the forces of hell, and so what?

"I'll show her," he muttered, with one final burst of something or other. And with that, he stopped his engine, and there, at the gates of so-and-so's house, with the rain thundering down on him, and all silence around him, Bill Powell consumed the two quarts of ice cream and hurled the empty containers furiously at the beauty's gates.

Then he drove off, convinced that with acute indigestion, acute pneumonia and acute everything, he'd die forthwith. He was glad of it. And then his engine stopped ... on a hill. ...

The car careened uncontrolled, with wet brakes, down the declivity. Bill changed his mind. He discovered he didn't want to die at all. He yanked levers and things, and still the car went. Bill shut his eyes and headed into the curb. WHAM...! The car stopped. Bill opened his eyes, and found he wasn't dead. He tried to start the engine and it wouldn't. He got out and kicked the car in the rear tire, and began to walk. ...

● A HALF HOUR later, he reached the Beverly Hills Hotel. The night clerk hid under the desk at the apparition. Bill stalked to a telephone booth and called his house. He fired his three servants, one after the other, for—
 (A) letting him go out,
 (B) not having the top of his car up, and,
 (C) not telling him it was going to rain.

Then he told them they were hired again, if they'd come and get him. One of them did, and so, at last, Bill got back home, full of rage and ice cream and rainwater, and went back to bed. He knew positively and absolutely, that he'd never wake up. And that if perchance he did, he'd have galloping tee-bee or pneumonia that'd take him off in 24 hours. And thus ended the night. ...

—and the next morning, Bill woke up. The sun was shining gloriously into his bedroom. The aroma of hot coffee came gloriously into his bedroom. Bill realized that he could smell it ...!

"My cold is GONE!" he crowed. And it was. And the little car was back in his garage, with the top fixed and the windshield replaced by a faithful servant. The world was bright—and *his cold was cured. ...!*

"But next time, I think I'll just try aspirin, instead," he says.

THE GREAT ZIEGFELD

WILLIAM POWELL
As "The Great Ziegfeld"

MYRNA LOY
As loyal, devoted Billie Burke

LUISE RAINER
As tempestuous, irresistible Anna Held

VIRGINIA BRUCE
A "Glorified" Ziegfeld girl

FRANK MORGAN
As Ziegfeld's life-long rival

FANNIE BRICE
The inimitable Fannie herself

LEON ERROL
With his trick knee

GILDA GRAY
The original "Shimmy" Girl, herself

RAY BOLGER
Eccentric Dancing Sensation

NAT PENDLETON
As Sandow, the Strong Man

ANN PENNINGTON
Herself, dimpled knees and all

HARRIET HOCTOR
Ziegfeld's Greatest Dancing Star

REGINALD OWEN
As Ziegfeld's Manager

A. A. TRIMBLE
As Will Rogers

BUDDY DOYLE
As Eddie Cantor

JOSEPH CAWTHORN
As Dr. Ziegfeld

W. W. DEARBORN
As Daniel Frohman

RAYMOND WALBURN
Sage, Ziegfeld's Press Agent

JEAN CHATBURN
Mary Lou, Ziegfeld's protégé

HERMAN BING
Ziegfeld's Costumer

WILLIAM DEMAREST
As Gene Buck

200 **GLORIFIED GIRLS** 200

Costumes by ADRIAN
Screen Play by WM. ANTHONY McGUIRE
Directed by ROBERT Z. LEONARD
HUNT STROMBERG Producer

A METRO-GOLDWYN-MAYER Picture

The Life and Loves of the World's Greatest Showman

2 YEARS IN PRODUCTION!
GREATEST MUSICAL HIT!

Now, in one flashing musical comes all that the great Ziegfeld gave the world in his crowded lifetime! American girlhood glorified...great Ziegfeld stars ...the melodies he made immortal... and a new "Follies" with all the lavishness of Ziegfeld! You follow his fabulous private life...his tempestuous romance with Anna Held...his deep and ardent love for Billie Burke...All in M-G-M's biggest musical triumph!

What They're Filming

William Powell and Carole Lombard in *My Man Godfrey* ... everyone appears cracked ... Powell wears red whiskers, home grown

. . .

in, standing close beside the signal man, never blinked an eye as he waved the very, very red flag in monotonous circles.

The rodeo scenes will not be all comedy by Messrs. Crosby and Burns. Many a champion cowhand will do his stuff, including Mabel Strickland, perennial winner at Pendleton (Oregon) and Cheyenne (Wyoming) round-ups.

To film the Garden scenes, a huge imitation stadium was built under cover of a large sound stage. The job was so unusual that an outside contractor did the work instead of the usual studio crews. More than 1,000 extras had to be seated for some of the shots, requiring more than 50,000 feet of lumber.

● FRANCES FARMER, BING'S LOVELY leading lady, has appeared in only two other pictures. Winner of a Seattle beauty contest, she traveled to Moscow, Berlin, Paris and London on prize money. Then, returning to America, she hired an agent who landed her a screen test. Incidentally, another contest winner also will have a rôle in this picture. Watch for Bessie Patterson, 18-year-old winner of the El Paso Sun Carnival beauty contest. A high school student in Hot Springs, New Mexico, Miss Patterson was graduated with honors six months in advance in order that she could come to Hollywood to make the picture.

Because many portions of the picture had to be filmed out of doors, Director Taurog and his crew made a long search for locations. Many a beautiful spot was found, but the director always faced the inroads of civilization. The script called for unimproved ranches, old time corrals.

The crew roamed over a wide area as far east as New Mexico before it returned in disgust, finally locating the right scenes 400 miles north of Hollywood.

My Man Godfrey

(Universal)

When we came upon the scene, Alice Brady owned the Pennsylvania railroad, the Boardwalk, three pieces of property in the Marvin Gardens section, and the Waterworks.

And she was just going to force Bill Powell's fine new hotel on Tennessee Avenue into bankruptcy. It was a tense moment. Thousands of dollars were at stake.

"Listen, you psychopathics!" boomed the voice of Gregory La Cava, their director— "if you don't come back to work I'll burn that dang game of Monopoly!"

Carole Lombard and Gail Patrick tossed several five hundred dollar bills onto the board and, arm in arm, walked to their place in the lights. Another scene for *My Man Godfrey* was underway.

In *My Man Godfrey* Carole Lombard is a reckless, dumb debutante. She and her sister (Gail Patrick) go to the city dump on a sociable game of scavenger hunt. To win the prize, they must return to the party at the Waldorf with a Forgotten Man—and a few hundred other items from goats to soup.

You've guessed it. William Powell is the Forgotten Man, sick of the revolting existence at the dumps. Gail tries to lure him to the Waldorf, waving a five-dollar bill in front of his nose. It's a grand scene!

The bright flood lights reveal Universal's exclusive city dump in all its reality. Powell, Lombard and Patrick are shivering along with everyone else. It's a cold night, as California evenings are apt to be. They blow on their hands, stamp their feet, try to keep nimble for the scenes.

But again, Patrick is waving a five-dollar note under Powell's nostrils. Something about it angers him just a touch. He gets up and menaces Gail. Step by step she backs up, with our William glaring balefully.

Then it happens. Gail trips, but Bill doesn't lay a hand on her. She totters for a brief second, then does the best pratfall you ever saw right into a mess of ashes.

Whereupon Gail flees in terror, leaving Carole here to handle Powell in her dumb, sweet way. She turns the trick by her straightforwardness, appears triumphantly at the Waldorf with her Forgotten Man.

The story ends here? Ah, no. Carole hires poor Godfrey as a family butler. Butling seems to be a brief career in this mad family, and we'll not go too far into the plot just now. Only it looks like a stormy time ahead for our man Powell.

● THE MOTHER OF THESE dizzy girls is played by Alice Brady, who in this case is no brighter nor smarter than her offspring. The father, poor fellow, means well but hasn't a chance. Eugene Pallette plays the rôle of papa millionaire.

It's a riot of fun around these main characters, and largely around Carole and her butler. You see, she falls for the goof from the very first, and gets into one doggone mess after another. Powell just can't return the sentiments—unusual fellow, eh what?

Grandest scene in the picture is the ballroom set at the Waldorf, with some 300 extras in dress clothes parading before the camera. Gorgeous gowns go completely into the background, however, when the scavenger hunters return with their goats, tin cans, violins, violets, bromos, wheel barrows, fire extinguishers, fruit stands, et cetera continuously. They bring back so much junk that you wonder where even the property department managed to collect it.

You're bound to enjoy this hilarious bit of comedy for a number of reasons. To be specific: (1) Greg La Cava, who lately has been directing Claudette Colbert, is megaphoning it; (2) it's bringing Bill Powell and his ex-wife, Carole, back into each other's arms—and you should see 'em; (3) it's a diamond studded cast with a platinum Cinderella story.

● TO SEE THE SUAVE, well-dressed Powell in the rags of a bum at a garbage dump is worth the price of admission alone. We asked him if that half-inch of reddish whiskers was his, and sure enough, he raised the beard all by himself. You'd never suspect he'd grow *reddish* whiskers. Carole and he sit rather close together, and seem to have much to say to each other. In spite of their marital rift, they actually are the best of friends. Carole grows more beautiful in each picture, and more popular as a comédienne. We can thank her for the trend toward swift-talking, sophisticated comedy. You can't make such pictures without a Lombard or two.

Gazing upon Gail Patrick, we can be glad we are not obliged to make such a choice as Bill confronts. Your reporter tips you off to watch Gail; aside from this delightful pastime which in itself will well repay you, there will be the added satisfaction of saying: I was one of her first fans. She'll be up there in the top billing one day.

Sorry we haven't time for more—Alice Brady is starting another game of Monopoly!

JULY, 1936

UNIVERSAL PRESENTS

WILLIAM **POWELL**
AS THE BUTLER

CAROLE **LOMBARD**
AS THE DEBUTANTE

in

"MY MAN GODFREY"

with
Alice Brady • Gail Patrick • Jean Dixon
Eugene Pallette • Alan Mowbray

From Eric Hatch's glorious Liberty Magazine serial "Irene, The Stubborn Girl," and "My Man Godfrey," the popular novel version

Produced and Directed by GREGORY LA CAVA
CHARLES R. ROGERS, Executive Producer

HERE 20TH CENTURY-FOX HITS ARE SHOWING!

The smartest musical ever filmed!
The grandest songs ever written!

"THIS YEAR'S KISSES"
"I'VE GOT MY LOVE TO KEEP ME WARM"
"THE GIRL ON THE POLICE GAZETTE"
"HE AIN'T GOT RHYTHM"
"SLUMMING ON PARK AVENUE"
"YOU'RE LAUGHING AT ME"

Dick POWELL · **Madeleine CARROLL**

in

IRVING BERLIN'S "ON THE AVENUE"

with

ALICE FAYE · **THE RITZ BROTHERS**
ALAN MOWBRAY · **GEORGE BARBIER**
CORA WITHERSPOON · STEPIN FETCHIT · SIG RUMANN

Directed by Roy Del Ruth · Associate Producer Gene Markey
DARRYL F. ZANUCK in Charge of Production · Music and Lyrics by Irving Berlin

The tops in swank! · The smoothest in rhythm!
The greatest in stars! · The newest in love!
The fastest in dancing! · The last word in entertainment!
It's full of Boom-Boom and Go-Go!

New York's latest real-life romance set to Irving Berlin's music in a show as big as the town... as good as the songs!

'S YOUR GUARANTEE OF THE BEST IN ENTERTAINMENT!

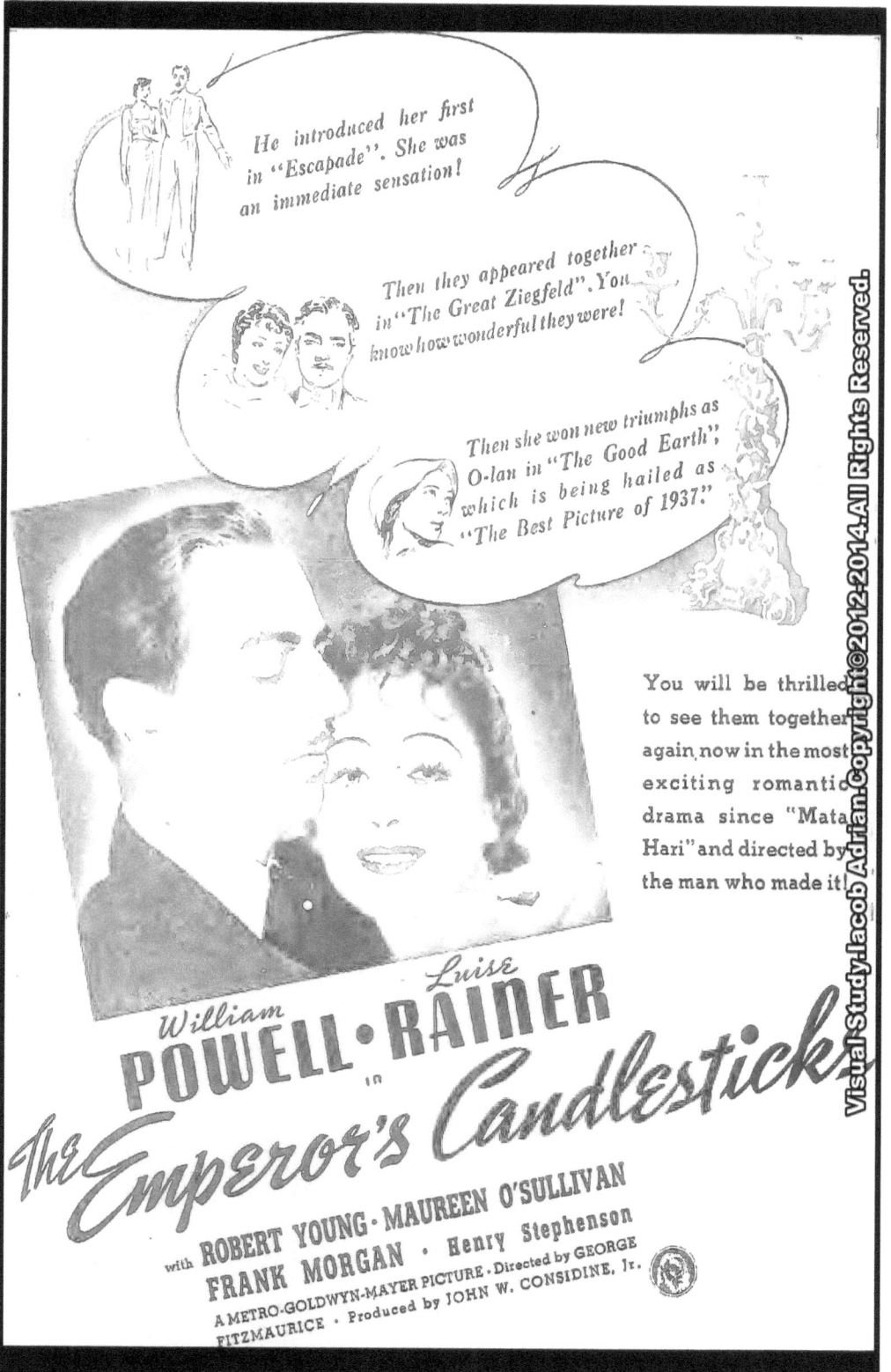

THE GAY LIFE OF HOLLYWOOD BACHELORS

By LEON SURMELIAN

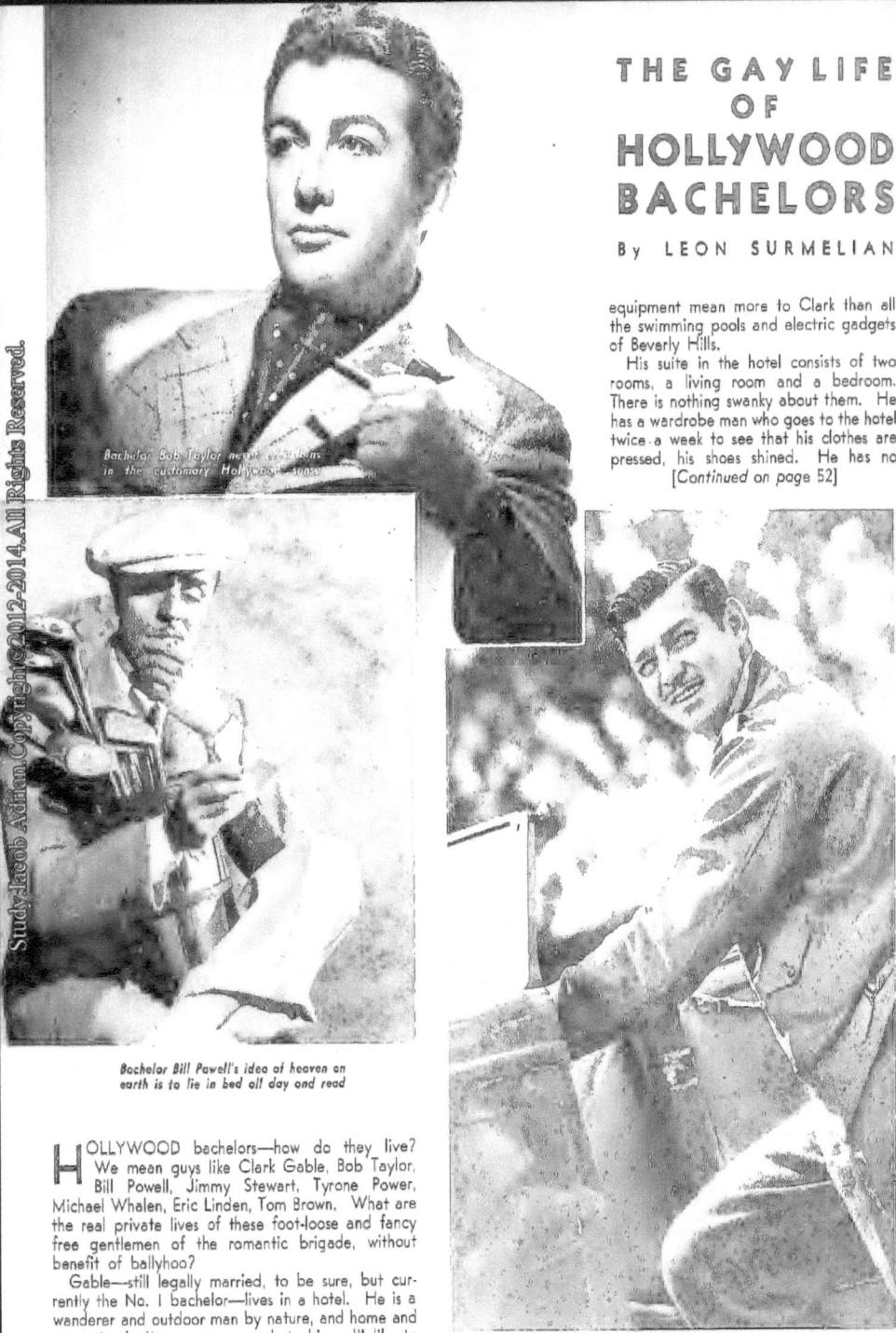

Bachelor Bob Taylor never exercises in the customary Hollywood sense

Bachelor Bill Powell's idea of heaven on earth is to lie in bed all day and read

Bachelor Clark Gable's idea of a party is to talk and play cards with two or three couples in the home of a friend

HOLLYWOOD bachelors—how do they live? We mean guys like Clark Gable, Bob Taylor, Bill Powell, Jimmy Stewart, Tyrone Power, Michael Whalen, Eric Linden, Tom Brown. What are the real private lives of these foot-loose and fancy free gentlemen of the romantic brigade, without benefit of ballyhoo?

Gable—still legally married, to be sure, but currently the No. 1 bachelor—lives in a hotel. He is a wanderer and outdoor man by nature, and home and property don't mean very much to him. "I like to live under my hat," he told us. "My Hollywood mansion is my station wagon." Hunting and fishing equipment mean more to Clark than all the swimming pools and electric gadgets of Beverly Hills.

His suite in the hotel consists of two rooms, a living room and a bedroom. There is nothing swanky about them. He has a wardrobe man who goes to the hotel twice a week to see that his clothes are pressed, his shoes shined. He has no

[Continued on page 52]

The Gay Life of Hollywood Bachelors

secretary, no servants. "I eat out all the time. For breakfast, usually I have a baked apple, cereal, coffee and toast. For lunch, a sandwich or two, maybe a salad. But I go to town for dinner. I have no favorite place to eat. When I am working, I lunch at the studio commissary."

You never see Clark Gable in Hollywood's celebrated night clubs, and he doesn't care to dance. "My idea of a swell Saturday night party is to talk and play cards with two or three couples in the home of a friend." He never entertains. Sometimes he takes a few people out to dinner, that's all.

Bob Taylor lives in a small, one-story house on a quiet street in Beverly Hills. He has a Hungarian servant, Joe. There is absolutely nothing about this place to indicate that a movie star lives there except the long arrays of suits in the closets and the stacks of freshly laundered shirts which Joe has a habit of piling up on beds and dressers. The living room, with its radio, books, fireplace and tricky little bar is such as any successful bachelor living alone might have. He sleeps in a small bedroom, almost austere in its simplicity. There is a guest room, a small gymnasium, bathroom and kitchen, all neat and spotless, but innocent of the arts of professional interior decoration. "I've taken another year's lease on this house," Bob said proudly. "I like it."

Bob loves to dance, anywhere where there is a good orchestra. He never entertains in the customary Hollywood sense. Now and then he takes a few friends to the Beverly Wilshire Hotel for a dinner dance.

BILL POWELL gave up his famous palazzo in an ultra-ultra section of the movie colony, apparently because he was tired of living like a lone emperor. His present house, a good-sized one, but far from being a palace, is located in the comparatively plebeian atmosphere of West Los Angeles. Instead of holding open house, he holds open court—for tennis players. He likes to entertain informally. He has a barbecue pit, and after the feast runs off a picture in his projection room.

"I'd rather have my friends come to my house than go out myself," he said.

Bill Powell has devoured a good-sized library. His idea of heaven on earth is to rest in bed all day and read. "I'm terribly lazy. If I ever build a swimming pool again, I'll have a moat dug around my house and swim round and round without the necessity of turning back after a few strokes. I think I'll also have a drawbridge."

James Stewart lives in Beverly Hills, with Joshua Logan and John Swope, two young men who are interested in the directorial and production end of motion pictures. A fourth member of this gang was Henry Fonda, now sane and married. "We had a swell house in Brentwood," Jimmy said, "but when Fonda got married we moved to a much smaller place and kept looking for another house. We had to wait another month before we found a house we liked.

"Before I came out here," continued Jimmy, "I had an idea that this was a wild town of Babylonian whoopee parties, that nobody came out of Hollywood unsinged, that by signing a movie contract you signed your death warrant, and all that stuff. Who gives those whoopee parties, I'd like to know! Why, this is the quietest town I have ever lived in, and I have never met so many nice, well-behaved people in my life."

Jimmy would like to marry and build a home of his own, "on a hill," as he explained. Remember that he studied architecture at Princeton. We were curious to know why he doesn't have a steady girl, why he steps out now with Eleanor Powell, now with Ginger Rogers or Virginia Bruce, and keeps the movie snoopers guessing. The color deepened in his cheeks. "I'm wondering, myself, why I don't have a special girl! In college, I usually went to the proms stag. I used to take girls to proms and house parties, but for some reason or other they were always whisked away from me." Jimmy doesn't seem to realize how popular he really is with the lovely peaches of Beverly Hills.

THE other day we lunched with Tyrone Power at the 20th-Century-Fox Studio. This slender, patrician six-footer with glittering dark eyes is a vital and vibrant chap, full of the joy of life, and are the gals crazy about him.

"I live with my mother in a little house," he said. "Our house isn't large enough to accommodate a lot of people, so I give only small dinner parties, or more often, go outside. I stay in two nights a week, to write letters and attend to business affairs. When I'm not working I like to go to Palm Springs. My hobbies are tennis, bowling and swimming. Most of my friends are non-professionals."

Baby Takes a Bow

By EMILY NORRIS

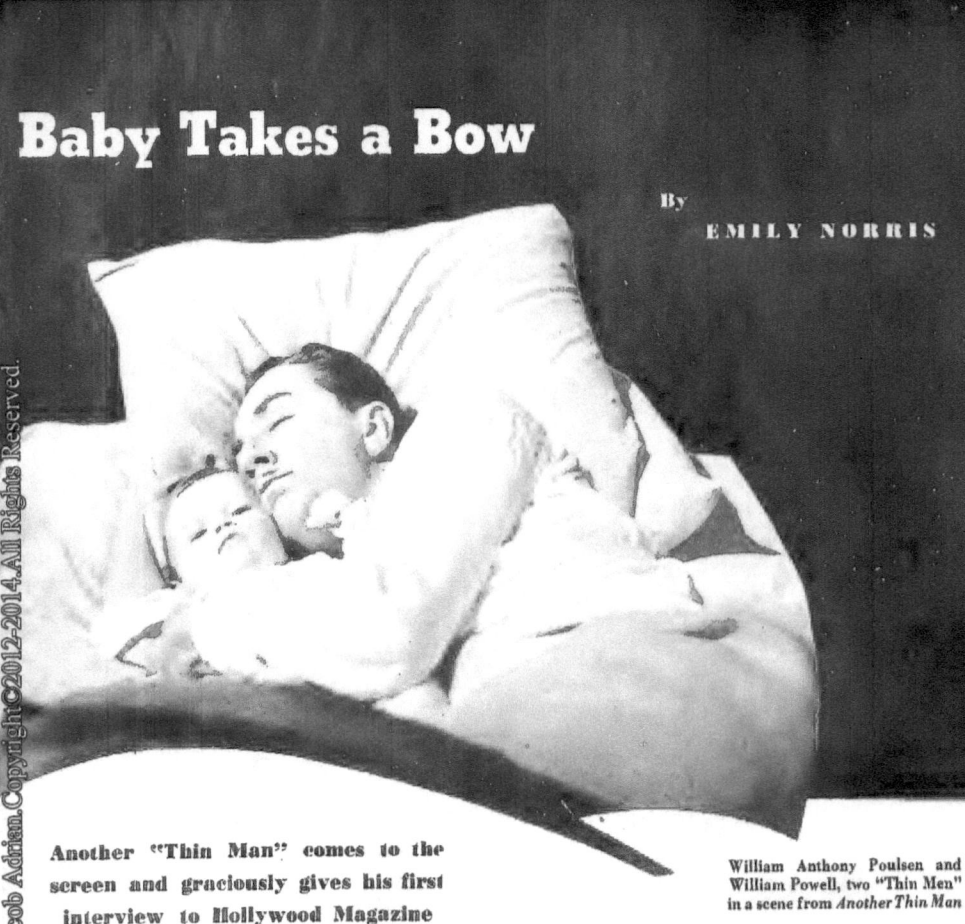

Another "Thin Man" comes to the screen and graciously gives his first interview to Hollywood Magazine

William Anthony Poulsen and William Powell, two "Thin Men" in a scene from *Another Thin Man*

It seems the underworld was giving the Thin Man's baby a party And park your guns outside, gents.

You remember how, in *After the Thin Man*, Myrna Loy sat knitting little pink things and Thin Man Bill Powell asked, "What're you knitting *those* for?" So Mrs. Myrna Thin Man said: "And you call yourself a detective!" Well, the eventuality in this new picture, *Another Thin Man*, is eight months' old "Cuddles." That is what the rest of the cast called him.

("A fine monicker for a detective's son!" Cuddles fumed in sign language when we had a moment alone. That is, alone with only a nurse or so and a representative of the Board of Education hovering around.)

Already the guests were arriving, and that corner of the M-G-M lot looked like a maternity ward. With sixteen babies scheduled for the party, of course they had to have forty-eight babies on hand. Huh? No, there's no mistake in mathematics. Count 'em yourself.

You see, the law allows a baby only so much time before the cameras and under the lights per day. Therefore, to expedite matters, sixteen of the first group of thirty-two infants acted as stand-ins for the other sixteen. The third group of sixteen were needed, because, according to law, the first group had to quit work by two in the afternoon.

To go with the forty-eight babies, there were forty-eight mothers, forty-eight nursing bottles, forty-eight "formulas," forty-eight sets of didies, eight studio nurses and a dozen gallons of milk. Before Director W. S. Van Dyke finished shooting the sequence he said he felt like a mother himself.

The idea was that the Thin Man, being a famous private detective, naturally had a lot of acquaintances who were pickpockets, gangsters, and what not, but who helped him out sometimes on his more difficult cases. In return for his kindness on many occasions when the world seemed against them, these acquaintances—hearing that the Thin Man had become a father—decided to throw a party (in a nice way) for his son and heir.

Each underworld character had been told to bring his own baby. And each did with one exception. He being babyless but eager to join in the festivities, rented an infant and passed it off as his own.

("This ought to be a warning to people not to go around renting babies," Cuddles confided, again in the sign language, as —rosy and smiling—he contentedly blew bubbles in his special dressing room while waiting to go on the set to act as host at the party. He raised tenuous eyebrows, mere fuzz really, at a particularly handsome bubble and added: "The consequences of that fellow's ill-considered baby-hiring—glub. Glub, glub, glub— you'll see, in due time.")

Now, the mugs (and that's the right word) who were giving the party had been picked by the casting director for their rugged features. Rugged? They looked as if they'd come through a blizzard of broken crockery. One by one the babes were handed carefully to these gentlemen an instant before the cameras turned.

The result, though unanticipated, was a

tribute to the infants' sense of civic righteousness even at their tender age. Without exception they took a look at the men designated in the script as their fathers—and burst into frightful howls of disapproval.

For probably the first time since talking pictures came in, nobody had to yell, "Quiet!" as the cameras rolled. The command wouldn't have been heard, anyway. Grips, juicers, extras, could not merely have conversed but given college cheers and still not been heard above that infant uproar. The mugs, pale beneath their makeup, looked terrified.

Things, though, had quieted down a trifle in the Thin Man's maple and cretonne living room, and Asta, the wirehaired terrier, was making friends with the guests while Myrna served cake and the Thin Man bragged about Cuddles, when word came that a cop was at the door. Well, you know how it is between cops and the underworld. The guests began to depart at once. In the excitement, the guest who had hired a baby picked up Cuddles, the Thin Man's child, in mistake for the baby he had hired.

("He left the rented baby, but Myrna and Bill didn't want it," Cuddles explained, placing his toe in his mouth. He went on smugly: "They liked me better." He omitted mention of the fact that the mother of the rented baby brought back Cuddles, fire in her eye, and demanded her own offspring in exchange. A nurse took Cuddle's toe from his mouth and put a nursing-bottle there instead. "Glub, glub," Cuddles murmured contentedly, his bright eyes twinkling his thanks.)

There was always a nurse near Cuddles, of course. The baby got more care than Bill Powell himself. Part of the attention showered upon the baby was prescribed by statute. He could "work" only four hours a day. During the four hours he could spend only four minutes right under the lights. And he could spend these four minutes at the rate of only thirty seconds at a time.

Talk about a star! The baby ordered Myrna and Powell around with the greatest complacency. For instance, they had to be right there, all set for the scene, before the baby was brought on. No waiting! No wasting one of those thirty seconds! Fortunately, Director Van Dyke is a fast shooter.

Then there was the matter of castor oil. Oh, not taken internally. No. But drops of castor oil were put in Cuddle's eyes before a scene to form a film as protection from the lights. They were put in after a scene also, for good measure or something. And the instant the scene began, the city welfare worker from the Board of Education would stand with gaze glued on a watch. Just try to work the baby five seconds overtime!

The nurse, as well as mother, saw to it that Cuddles had his naps promptly, and his feedings—there was a little electric plate in the dressing room for heating milk. The dressing room was as scrubbed and sanitary as a hospital corner. No, the salary check didn't have to be sterilized.

("Myrna and Bill said," Cuddles remarked, "that it was quite an education for them, watching me taken care of, and taking care of me. In the picture, they had to change my—ah—underthings. They didn't know how, at first." He gave a toothless grin. "I had to laugh.")

The entire cast laughed at Myrna and Bill somewhat later, though the laugh had nothing to do with Cuddles. It had to do with two surprise parties on the set, in addition to the one given to Cuddles in the script. Myrna and Powell have birthdays within a few days of each other, and three or four times it has happened that they worked in a picture together on those days. It's become increasingly hard for them to surprise each other, but this time they outdid themselves.

On his birthday Bill was about to go before the cameras when somebody told him that a Mr. Gwynn, friend of one of the M-G-M producers, was waiting in Bill's dressing room. "But I can't see him now!" Bill protested. "You must," the messenger insisted, "He's a friend of So-and-So." "All right," Bill said, exasperated, and rushed to his dressing room.

When he threw open the door, there stood a live penguin, dressed to resemble Powell, studying itself seriously in the mirror. Upon its back, turned toward the door, was a sign: "Happy birthday from one Thin Man to Another." Powell burst out laughing. "Well, he has my nose and chin," he remarked. On his return to the set, he found tables decorated and ready for the big party that followed the day's shooting.

Came Myrna's birthday, and she was determined to be surprised at nothing. But right away Bill surprised her. Nailed on her dressing room door that morning when she arrived was a great printed notice: "SURPRISE PARTY FOR MYRNA LOY—COME ONE, COME ALL!" At noontime, a town crier walked across the set, ringing his bell and announcing that there would be a surprise party for Myrna. In the course of the afternoon, they turned on the radio during a rest period and heard several local stations sing: "Happy birthday, dear Myrna" and announce a surprise party for her. By the time the party started, after the day's work, nobody in town including Myrna was unaware of the fact that Myrna was going to be very much surprised. Asta the terrier was at the party. So was Duke.

Duke is a huge Irish wolfhound when he stands on his hind legs, he is around seven feet tall. In one scene, he was supposed to greet Powell menacingly with his paws on Powell's shoulders. Powell loves dogs and vice versa. Duke, affectionate in proportion to his size, wouldn't menace. He insisted on trying to lick Bill's face. "In place of a necktie, I'll have to wear a strip of bacon so it'll look as if he were going for me," Powell suggested.

Myrna Loy manages the two "Thin Men" with admirable fairness in a scene from the newest comedy in the series

Baby Takes a Bow

Then, in fun, he growled at Duke. The dog automatically growled back. It recorded fine in the sound track and they let it remain; cutting out the next few feet when Duke in a frenzy of repentance nearly drowned Bill with kisses.

("They played tricks, too," Cuddles related with a yawn; "it kept the grown-ups amused, I suppose.")

They played tricks, indeed. Such as giving that trick-player, Nat Pendleton, a loaded cigar and placing near him a prop man with an empty revolver. When the cigar went off, Pendleton thought the gun had exploded and shot the cigar from his mouth. The same day, Van Dyke (who is W. S. Van Dyke, II., while his small son is W. S. Van Dyke, III.) asked Powell to choose a baby to appear at the party called for by the script. "It must be kind of a sophisticated baby," the Director said.

Powell looked over the aggregation of infants. "How about that one?" he asked undecidedly. "Oh *that* one?" Van Dyke suggested, pointing to the back row. Powell looked and nearly dropped in his tracks. There sat a baby, in white coat and little white bonnet, smoking a pipe! Van Dyke had slipped a midget in among the tots. "Oh," Powell said, "W. S. Van Dyke, IV!"

There's a strange thing about the character of *The Thin Man*. In the first story, the original "Thin Man" was the victim, both in the book and in the picture. But by an odd, mass-misconception, the title was transferred by the public to Nick Charles, the sleuth so suavely played by Powell. Nowadays, the detective remains "The Thin Man" even though he isn't thin.

The victim in this third film about the doings of Nick Charles, is C. Aubrey Smith. He was pleased when he learned that he had been chosen to play a Wall street millionaire who got killed. In his long career on stage and screen he had, Mr. Smith pointed out, played everything except a corpse, and he felt that this character rounded out his experience. As for Otto Kruger, who plays the district attorney, he's been a district attorney so often that the role is second nature, but he said Mr. Smith was about the most distinguished "case" with which he'd had to deal. "Everybody's satisfied," Mr. Smith said jovially, awaiting the fatal bullet.

("I had a good deal to do with it," explained Cuddles with a complacent air; "if it hadn't been for me, Dad—the Thin Man, you know—would never have heard that revolver shot.")

The baby, in fact, had wakened his parents at midnight. Myrna quieted him and then put him in Powell's bed. But he didn't stay put.

("I craved amusement, intelligent conversation," Cuddles said, "so—glub, glub—I hi'sted myself up and crawled over Dad's face. It always wakes 'em." He crowed gleefully, then instantly grew solemn, staring about his dressing room with those bright, twinkling eyes.)

What was he thinking about, anyway?

("I'm thinking about my future," Cuddles replied, wrinkling his tiny nose in sign language parlance. "I'm going to be a detective, too. Already when they don't watch me I crawl around the floor looking for clues.")

Olivia de Havilland is preparing for her next picture, *The Sea Hawk*, with hours of sun on the tennis court

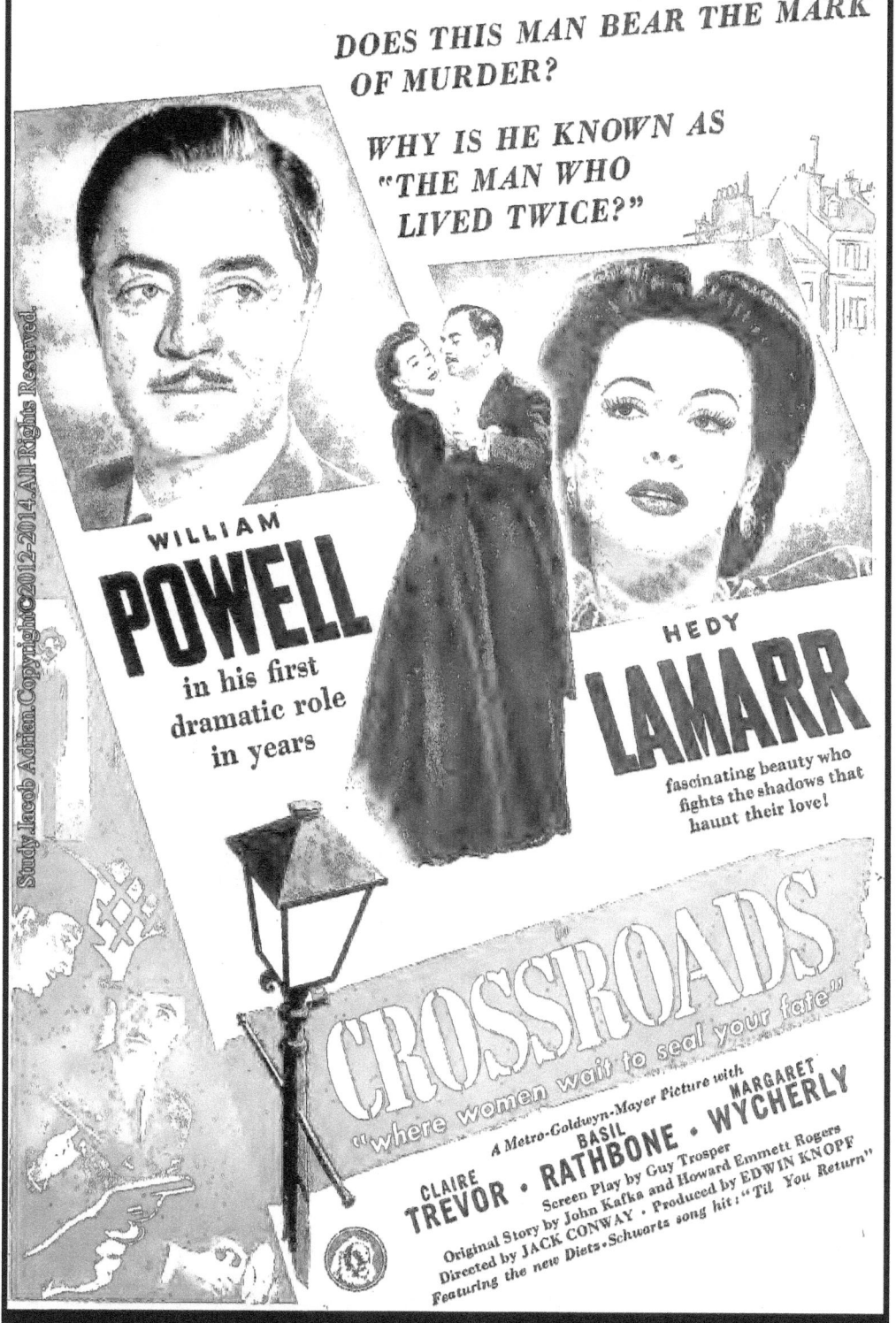

THE MAN IN THE MIRROR

There had been many lean days for "The Thin Man" but William Powell now rides the crest of the wave of movie popularity

By CHARLES DARNTON

PLAINLY, The Thin Man had outlived his lean days. Not that he himself betrayed any sign of growing obesity. Far from it, he was in his best form, just as advertised and true to his waistline. It was in the spirit, rather than the flesh, he gave the impression of living a full life.

Evidence of it was all about him in his Beverly Hills home. For no sooner had a houseman let me in than a butler popped out, solicitous as to my inner welfare. Could he bring me something? A cocktail? Perhaps tea and toast? Then a cup of coffee and a bun? With each hospitable suggestion I felt myself taking on weight alarmingly.

How, in these plumpish circumstances, did The Thin Man manage to look his weighing scales in the face every morning? Was he, throughout his waking hours, plied with food and drink? Did he set great store by the nourishment at hand? What, then, did he value most of all?

Here you have it in one word: Personality.

"But what is it?" William Powell wanted to know. "It's nothing we can put our hands on. We can't even say anything definite about it. It's that unknown quantity X. Yet somehow, mysteriously, it's there in some cases."

"Yours, for example."

"I don't know about that," he hastened to say. "But I do know that if Greta Garbo and Marconi were appearing in halls on opposite sides of the street and people could see them free of charge one hundred persons would go to Garbo where one went to Marconi."

"You're not doing so badly yourself," I reminded him.

"I feel a bit guilty," he confessed from a pew-like window seat. "God put a silver spoon in my mouth—thank God—but I don't know why He did.

"I think," proposed my resourceful host, "a highball would help."

It did. Scotch, like confession, proved good for the soul. With first aid in his "Here's how" hand and a stained-glass light shining through it he revealed:

"I'll let you in on a shameful secret. I look at myself in the mirror and see a guy looking back at me. Naturally, I want to give him the best of it, but for the life of me I can't see anything unusual in him. And there's one thing, above all others, I can't understand. Forgive me for overworking the personal pronoun, but I know any number of actors who are easier to look at than I am and much more competent, but many of them are not stars and I am a star. Why?"

"Personality." You can't help handing it to a guy so disarmingly on the level about himself.

But Mr. Powell shook his head with: "Looking at that guy in the mirror, I don't know. What makes a star? Whatever it is, it may have something to do with personality—but what the devil is personality? Why does anyone come to see me on the screen when he can go and see far better actors? It certainly isn't because good actors are to be found anywhere, for you can't pick 'em out of the bushes. Then why pick me for a star? What have I that those others haven't got?"

Tunefully, George M. Cohan's old song, *"Personality,"* was running through my head, but to save my interlocutor a possibly fatal nervous shock I didn't let it go any further.

"Would you say," I compromised, "that personality is a star's stock-in-trade?"

"Odd you should bring that up," remarked Mr. Powell. "We were talking about it only the other night, after seeing Fred Astaire in 'The Gay Divorcee.' In five minutes he won me. It was not his marvelous dancing nor his singing, but the man himself, his charm, personality, call it what you will. Now Astaire, as you know, is no Adonis, not irresistibly good-looking, nor is he the accepted romantic type of actor. Before his astonishing triumph in 'The Gay Divorcee' he had been known only as an uncommonly fine dancer. Yet his is the most decided example of personality I have ever seen. That's the amazing part of it. No one, certainly, had considered him to be star picture material. But suddenly, unquestionably, this young man has become the greatest new star motion pictures have known in years. How do you account for it, if not by personality?"

"Maybe by getting his 'break.' When and how did you get yours?" (The trouble was to get this man Powell to talk about himself.)

"In 1920 on the stage in 'Spanish Love,'" was his strictly informative reply. "Before that I had put in four years with

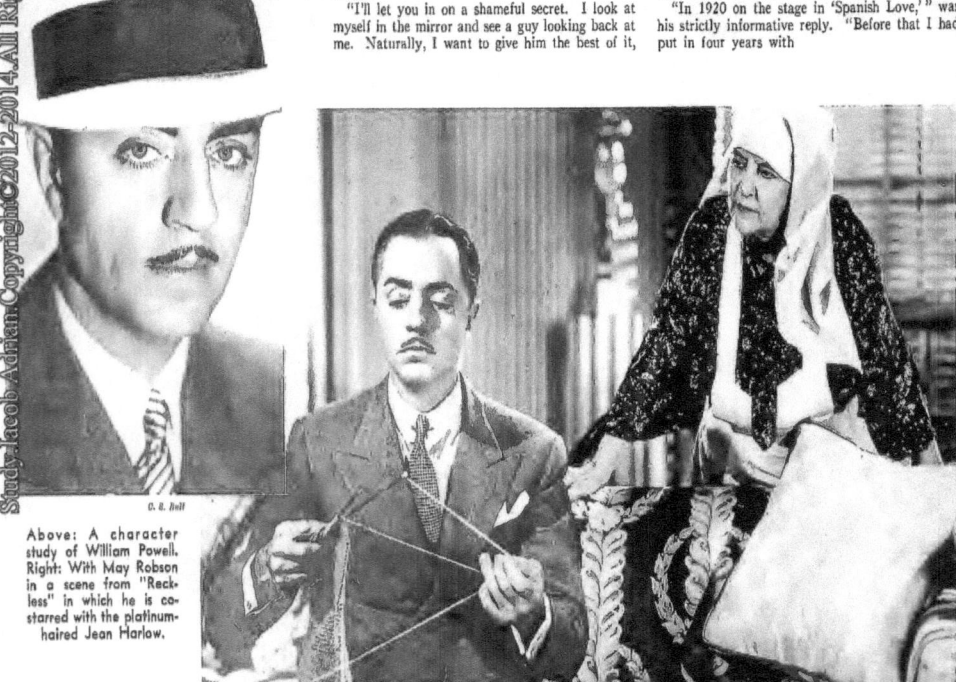

Above: A character study of William Powell. Right: With May Robson in a scene from "Reckless" in which he is co-starred with the platinum-haired Jean Harlow.

The Man in the Mirror

stock companies, then more years in plays which were tried out in dog towns, but never got to New York. We'd rehearse, then flop. But finally my luck turned at Maxine Elliott's Theater. In 'Spanish Love' I died of love and a stab-wound, a magnificent death—the actor's delight. That brought movie offers, and I had my first picture experience a year later in 'Sherlock Holmes' with John Barrymore."

"When did you become an actor?"

"I believe," he thoughtfully considered, "it was at the ripe age of one, possibly two years. It seems I stood up in my high-chair and delivered a stirring declamation, perhaps inspired by a pin in my nervous center. Then and there it was decided I was to be not an actor but a lawyer. The question was, what is Willie going to be? Not why is Willie going to be it? High school found me going in strongly for public speaking and knowing as much about law as I did about pearl fishing in the South Seas. Then in a school play, 'The Rivals,' I had the part of Captain Absolute. That settled it. I was seized by a burning, even seething, desire to be an actor. But my ambition needed financing, so I went to work as a clerk in the Kansas City telephone office. There, sitting with my back to the chief auditor, I developed marked ability as a left-handed eater. My boss could see what my right hand was doing—writing—but I didn't let him know what my left hand was up to. It was, from time to time, up to my mouth from a partly opened drawer with bits of a sandwich and streamline delicatessen. In short, I managed to eat my lunch in office hours so that I would have the whole noon hour in which to go to a movie.

"I'd planned," he explained, "to earn enough to pay my way through the Sargent dramatic school, but I had a devil of a time getting the necessary money to take me to New York. After working from September to December for fifty dollars a month I owed my father thirty-five dollars. Something more productive had to be done, so I wrote my great-aunt that unless she sent me seven hundred dollars she would be depriving the world of a great dramatic genius. The money arrived and with it my great moment. I did what every man-Jack of us probably has wanted to do at one time or another—walked up to my boss and proudly announced, 'I'm quitting!' My aunt, bless her—but wait a minute," he broke off, jumping up, "I've something upstairs that may amuse you."

Back with a scrapbook, Mr. Powell read me a vaguely familiar "notice" of the opening New York performance of "Spanish Love" which gave him first place among the actors and thoroughly approved of his dramatic behavior.

"I sent that review to my aunt," he added, then handed me the book with a whimsical smile and the suggestion, "The writer's name may interest you."

"Then it pays to be an actor—that is, a good actor?"

"Well," he granted, "it pays to be a successful actor—I don't know that the two are synonymous. There's no question about motion picture acting being a highly paid profession, but it's not so highly paid as the public is led to believe. For example, Constance Bennett is said to get thirty thousand dollars a week. People reading that report jump to the conclusion that if she stayed on the screen for twenty years she would make over thirty millions. Of course, that's ridiculous. The actual fact is that Miss Bennett had a contract to do two pictures of five weeks each at thirty thousand a week. But sixty, anyway forty, per cent of that goes to the government. Then there are her personal expenses. That's the way it is with all of us. By the time a year rolls around those huge salaries you hear about aren't nearly so big as they seem. For one thing, there's the upkeep of the star's position. Now I could live in a hall bedroom. I could live as a miser, but if I did it wouldn't help me. People would say I was stingy, and that would hurt me professionally. If you don't live like a success and look like a success the whispering public soon has word going round that you're the kind of tight-fisted star who'd choke a nickel to death. All the world comes to Hollywood, it comes to our door, and so it is necessary to have a place to receive that world. I'm compelled to have a decent sort of house where I can decently receive people. This isn't swank, it's business. I have to keep up a front because of various things connected with my business. What's more, a picture star has to live up to the figure he becomes in the public eye."

In my mind's eye I saw one of the very few American screen figures that can look at home in a top-hat and at the same time keep under it a lot of good, sound common sense.

"You know," gravely reflected Mr. Powell, "an actor's life is no sinecure. In fact, it's rather pitiful. This is particularly true of the stage actor, continually facing uncertainty and realizing that only the rare few can become financially independent stars. I often used to think about it when I was sitting around the Lambs Club. Once I got over being stage-struck there were other things more important to me—comforts and the ability to take care of myself. I saw what happened to actors and began casting about for something that would give me more security, to wit, motion pictures. And inasmuch as they've been pretty kind to me I feel kindly toward them."

Out of them he had just built a fine house in the higher and more spacious reaches of Beverly Hills. Somehow, I imagined it to be a bride-trap.

"No," he smiled, "just another investment, and this time, I hope, a good one. And I'm looking for returns. If there's any place in the world to which retired wealth will come—granting there's any retired wealth left—it's Hollywood. But if I don't sell it, I'll live in the house myself."

"Alone?"

"Well," he admitted, "I've no violent objection to beautiful women. If one should happen along I won't, of course, hang out the 'forbidden' sign."

We drank to her, the unknown beauty, and let the real estate go dry.

"Meanwhile," he added, "I'm going to keep on working as hard as I can."

"Going to do another 'Thin Man'?"

"They're writing one now. Of course, we're sticking our chins out. You never can tell about a sequel. But the first was delightful and easy to do—it just rolled out in forty days. The second may not be so easy, and the only thing I can be sure about is that it is an individual vehicle."

"Carrying personality?"

"Let's hope so," begged Mr. Powell. "As I said, I don't know what personality is, but I do know what it does—it makes all the difference between a feature player and a star."

As definitions go, that's telling it!

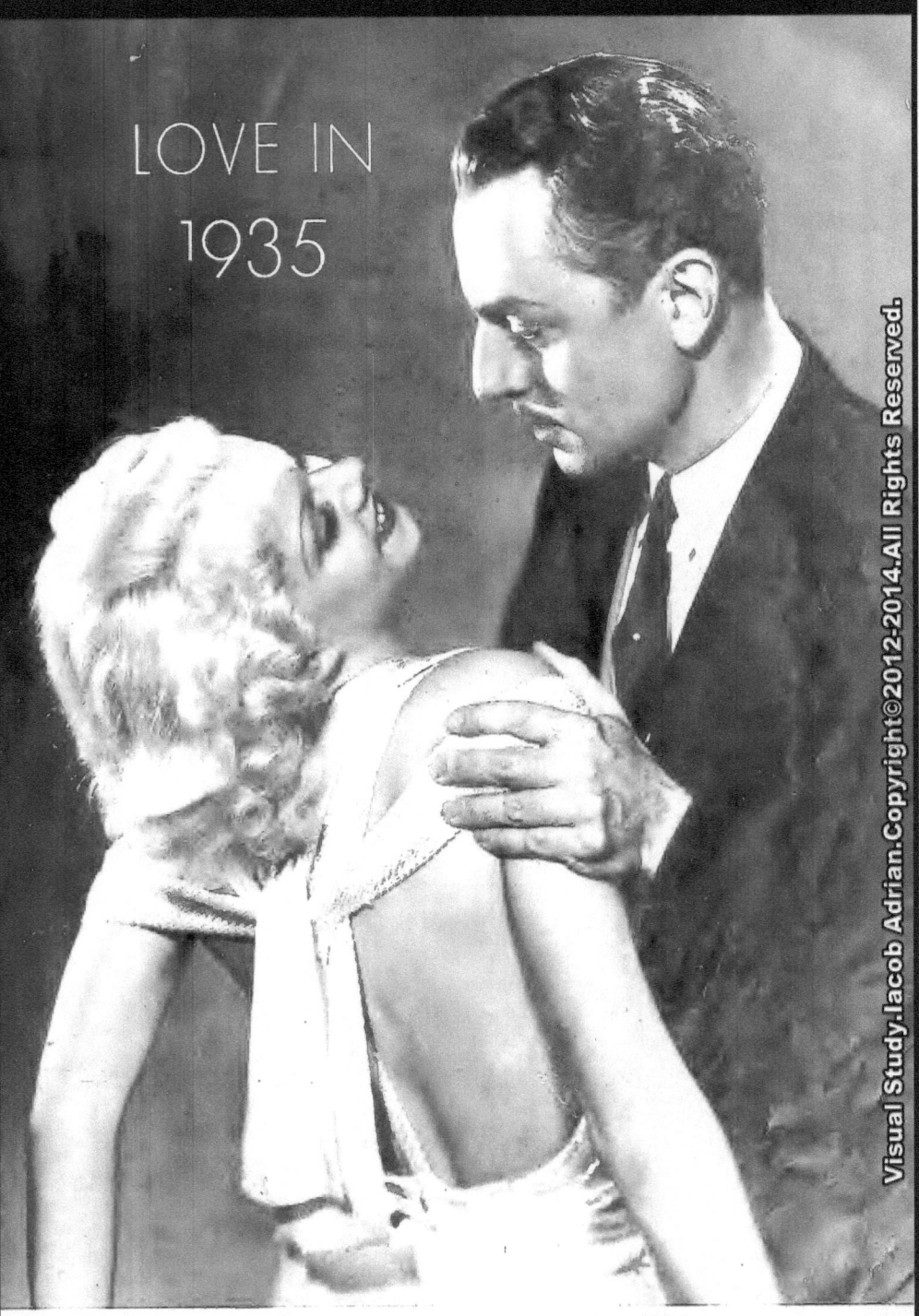

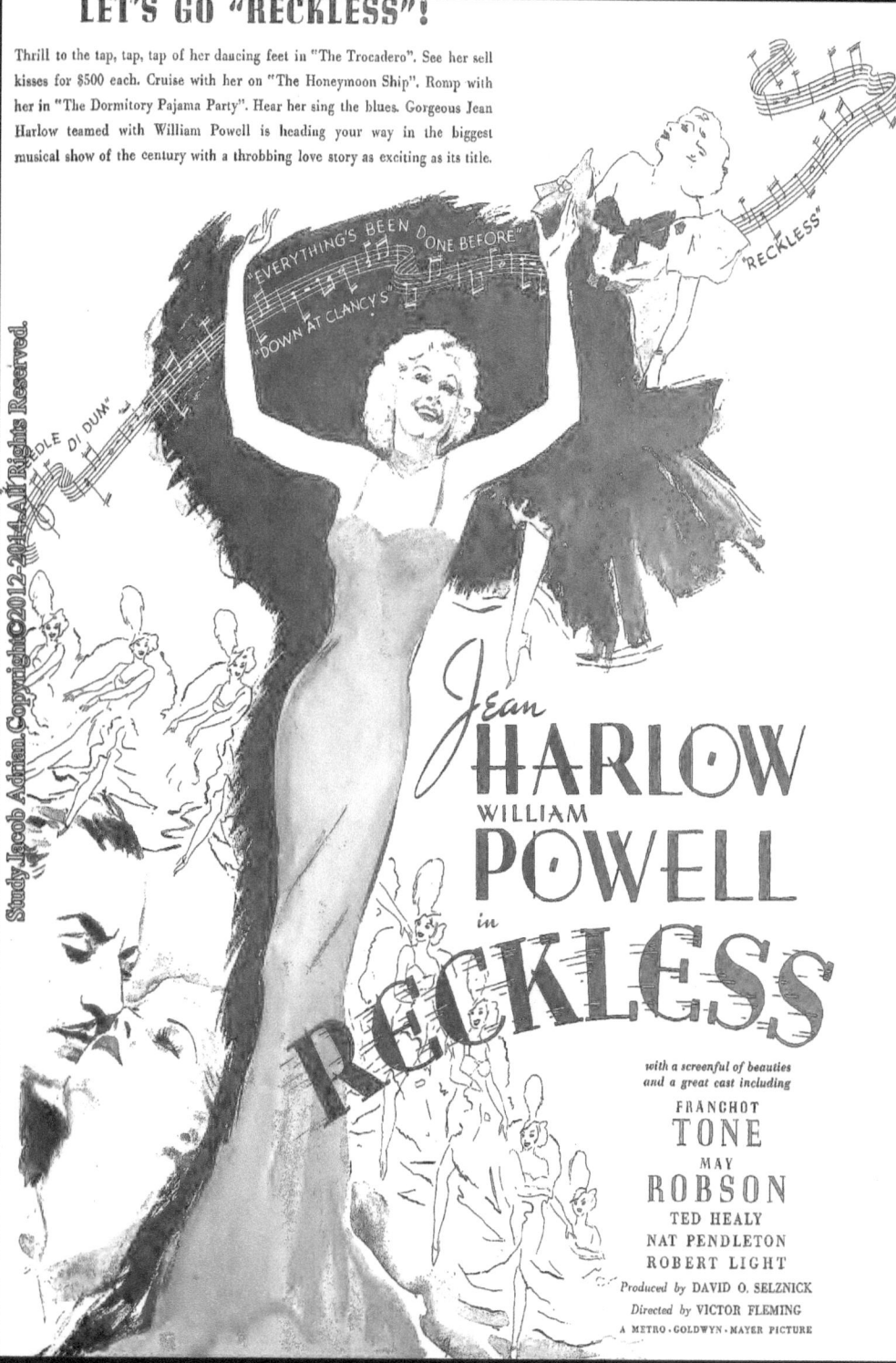

Discovered

IN A HOLLYWOOD PROJECTION ROOM!

Together, A GREAT STAR and a NEW STAR!

The hush in the Metro-Goldwyn-Mayer projection room turned to a muffled whisper... the whisper rose to an audible hum... and in less than five minutes everybody knew that a great new star had been born—LUISE RAINER—making her first American appearance in "Escapade", WILLIAM POWELL'S great new starring hit! It was a historic day for Hollywood, reminiscent of the first appearance of Garbo — another of those rare occasions when a great picture catapults a player to stardom.

WILLIAM POWELL in
Escapade

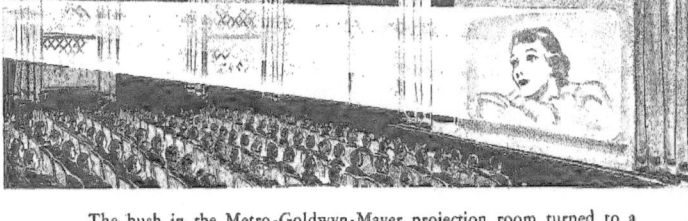

with
LUISE RAINER
FRANK MORGAN
VIRGINIA BRUCE
REGINALD OWEN
MADY CHRISTIANS

A Robert Z. Leonard Production
Produced by Bernard H. Hyman
A METRO-GOLDWYN-MAYER PICTURE

William Powell adds another suave characterization to his long list of successes... and Metro-Goldwyn-Mayer swells the longest list of stars in filmdom with another brilliant name—Luise Rainer!

Aristocrat, sophisticate, innocent — one wanted romance, the other wanted excitement — but one wanted his heart — and won it... sparkling romance of an artist who dabbled with love as he dabbled with paints... and of a girl who hid behind a mask — but could not hide her heart from the man she loved!

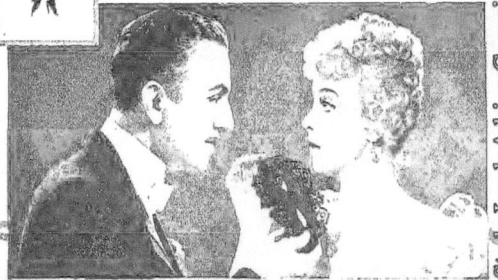

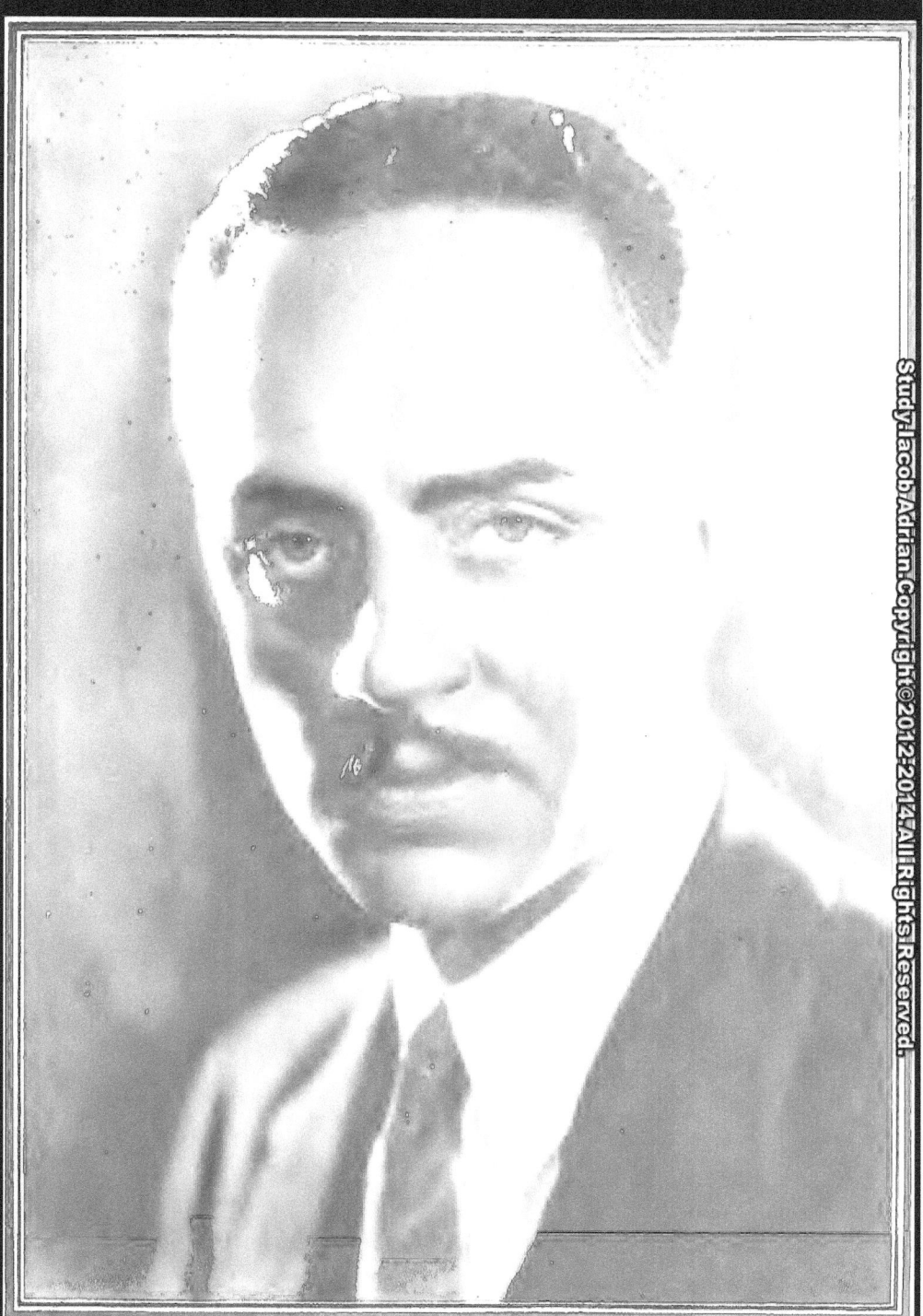

WILLIAM POWELL

WILLIAM POWELL — Coming villains cast their shadows before! An unusual camera study of our favorite, Philo Vance, the swanky detector of crime. And Bill's suave screen scoundrels are the last word in de luxe sinistering.

Their FIRST JOBS

to school, but instead I'd go to my chum's house, put on a pair of long pants that belonged to his older brother, and go down to work at my job.

"I earned two dollars a week. I saved up until I had $102, I remember—so that I must have worked nearly a year—and then I took the money home and gave it to my mother. She cried and kissed me, but told me I must go back to school."

Joan Crawford

JOAN CRAWFORD waited on the table to work her way through boarding school! That was her first job, but as she got no money for it, she doesn't feel that it was a real job.

Her first paid work was selling dresses in a department store in Kansas City.

"I got twenty dollars a week, and I spent every cent of it on clothes for myself," explained Joan. "I always adored clothes, but never had been able to afford nice ones. I worked a month, and by that time had a fairly decent outfit of two dresses, a coat and a hat. I felt very luxurious indeed.

"One day a famous actress who happened to be playing in town came in. A thought struck me—why shouldn't I become an actress? I had always loved to dance, had done some theatricals at school, and was good at imitations. I resolved to go to New York and seek my fortune."

James Cruze

"WEEDING an onion patch and milking six cows a day was my first job," announced James Cruze. "I earned twenty-five cents a day, and I was fifteen years old.

"I was working on a farm in Utah," said Jimmy, reaching for a cigarette, clad as always in his white flannels when he remains at home, as we chatted in front of the big fireplace in the hospitable Cruze home.

"I had been reading books of adventure, and, as I bent my back over the onion patch, it seemed to me I must do something to see the world.

"One night I decided to

Richard Arlen, at the age of eight. In those days, Richard arose at five thirty mounted his bicycle and delivered the morning paper to 165 homes.

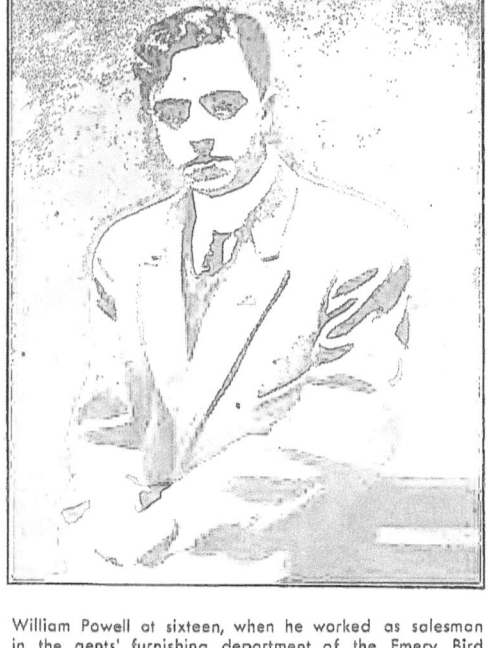

William Powell at sixteen, when he worked as salesman in the gents' furnishing department of the Emery Bird Thayer Dry Goods Store in Kansas City.

run away and seek my fortune. I tied some things up in a little bag, got up before daylight and was on my way. I bummed my way to San Francisco, meeting up with tramps and other aimless wanderers, slept on top of box-cars and in box-cars, and finally was in 'Frisco.

"The water front fascinated me, and I decided to go to sea. I was down to my last cent, and one thing that prompted me to ship aboard a freighter was peeping through into a cabin and seeing a table laid for dinner.

"I came back from my trip around the world with a fortune of $300."

Louise Dresser

AND the distinguished Louise Dresser once worked for the Peruna Company!

"That was my very first job," said Louise, "though afterward I worked at different things before I went on the stage.

"It was the Winter after my father died, and I felt that I must do something. I was fourteen years old, and felt that I should be helping to support my mother. Father had been killed in an accident, and mother was ill.

"The Peruna factory was located near where we lived, in Columbus, Ohio, and I went one morning and applied for a job. There didn't seem to be much that I could

The Hollywood Stars Come Right Out and Tell

Buddy Rogers, at the robust age of seven. At that time he swept out his father's newspaper office in Olathe, Kansas, earning a dollar a day. After school, Buddy delivered his father's papers.

do except to stamp envelopes, and I was set at that task, my salary to be $3 per week.

"But alas, I was fired at the end of three days! I simply wouldn't use the patent device for wetting the stamps, insisting on licking them, and I was so slow that they decided to part with my services. But I came home with my dollar and a half for the three days, and gave the money to my mother."

Charlie Mack

"MY first job," grinned the genial Charlie Mack, who is one half the brace of Two Black Crows, you know," was selling newspapers. I was only six years old and didn't know how to make correct change if the customer handed me more than a dime!

"I made about fifty cents a week. I had a husky voice even then and knew how to slur words so as to make it sound as if I might be calling news of a great disaster or something sensational like that. I sold papers until I was eleven.

"I was in a strike of the newsboys once. We struck for more papers for less money. Say, I settled that strike by intimidation! The publisher of the *Tacoma Ledger* always wore a tall silk hat. I stood behind a signboard every day and threw vegetables, mostly soft tomatoes, at the hat, as he came by. He finally discovered me, dragged me out, scared to death, but I must say he was a good scout. He conceded to the newsboys' request when I tremblingly explained. I suppose he felt he must save the cost of high hats!

"I became a messenger boy when I was eleven, and worked on a percentage basis, earning about three dollars a week.

"I used to sing around different clubs and such places to earn a little extra money."

Ramon Novarro

IF Ramon Novarro hadn't happened to pull two teeth at a time, instead of the one he was supposed to pull, he would probably still be working as a dentist!

"My father was a dentist down in Mexico," Ramon narrated, as we sat in his dressing-room while he made up. "My mother was very anxious to have me follow in his honorable footsteps, said he needed help, and that together we could make a fine living. I was to receive five dollars a week.

"So I went in and learned the laboratory work. My fingers were deft and I soon learned to do all the work there. I was about fifteen then.

"But I hated to see people hurt, to tell you the truth, and shrank from working at the chair. But finally the day came when father said I must begin to do practical work on patients.

"An old lady came in that day to have a tooth pulled. She had just three teeth in her head. Two of them were together. I got to work, and I did a clean job all right—too clean, really, for when I got the forceps out and looked at them, I had taken out two teeth instead of one! I don't know how it ever happened.

"Crestfallen I made a leap for the laboratory and closed the door. The astonished old lady hadn't time to recover before father, with quick wit and tact, told her that both teeth were bad, and that he had told me to take them both out.

"But I decided dentistry was not for me."

Dorothy Mackaill

"MY first money was earned on the stage. I had always been crazy about the stage, even in my obscure English village," said Dorothy Mackaill.

"Finally, wrapping up a few clothes, and taking what money I could get hold of, I ran away from Hull in England, to study dramatic acting at the famous old Thorne Academy on Wigmore Street, in London.

"I hoped that when my money ran out my parents would send me some more. But they didn't. I got down to my last ha'penny, so that I hadn't even anything to eat but a few biscuits, and then decided I must have a job that would give me free time for studying drama at the Thorne school.

"One day, when I had tramped about and was almost discouraged, I met a chorus girl through another friend of mine. She took me to the dance director of the Hippodrome chorus. I had studied dancing, but the director was hard-boiled. He declared I was a 'terrible 'oofer,' but let me do a song and dance for him. That decided him in my favor, and I got a chorus job. They hid me in the back line, but soon decided I had improved enough to lead a number. That number presently was chosen as part of an International Revue in Paris."

Monte Blue

"I WAS a funny little figure, I guess, as I came forth from the orphan asylum that had sheltered me ever

Dolores Del Rio, at six. Miss Del Rio was going to school in Mexico then with not a thought for Hollywood or movies.

All About Their First Jobs and First Earnings

since I was a tiny boy, after my father died. I was wearing the orphanage clothes, and was tall and lanky. I was sixteen, you see.

"Truth to tell, I felt pretty scared at having to go forth into the world to earn my living. It was a cold, wintry day, with snow three feet on the ground, too, which didn't add to my cheerfulness. But go I must, because a man who had once been in the orphanage himself had a job for me, and at sixteen you had to leave the institution. My job was to be printer's devil—that means 'kicking press,'—meaning in turn running a small printing press by means of hand and foot."

I was having dinner with Monte Blue and his wife in their beautiful new home in Beverly Hills, and we were surrounded by beauty and luxury. Monte has come a long way since those homespun days in the Indianapolis orphanage.

"The work was terribly hard on my unaccustomed muscles. Ever see anybody kick press? They have electric motors to do the work now, but in those days, for printing handbills and such small jobs, a boy stood constantly at a machine, keeping the foot piece going with his foot, and feeding paper into the press with his hands. Ten hours of this will tire out anybody not used to it. Of course I grew accustomed to it.

"I earned about three dollars a week, and saved my pennies to go to the theater. I used to hang around the stage door and try to get work, too, after the show. It was a long way to the theater from where I lived, and I used to walk there and home again."

Gary Cooper, at seventeen, was going to High School in Helena, Montana. He invested all his savings in a motorcycle

Norma Shearer

"I WENT to work in a music shop, to play the piano and sing the new songs," said Norma Shearer. "No, not for fun—because I had to work.

"I stayed in the shop three days, and never drew any money for my work because I hadn't the nerve to go and ask for it. I was supposed to get ten dollars a week. I consider that man still owes me $5!

"Guess I didn't like the work very much, after all. And mother found out I was working. You see I hadn't told her. She didn't like my working there. I don't really think I was much of a success," laughed Norma. "It seemed to me that every time I played a piece for a customer, he or she didn't buy it!

"Then we sold the family piano and went to New York, mother, my sister and I. I was sixteen then. I wanted to go into musical comedy, but couldn't get a job. Finally my sister and I got into a picture, playing sister rôles."

Edmund Lowe

"I SOLD papers at the age of four—but not in the usual way, no-sir-ee!" exclaimed Edmund Lowe, when I asked him about his first job.

"I was more enterprising than most youngsters, you see. So I collected all the old papers I could find in

Anita Page, at 12. Long before she thought of studying acting and trying for the motion pictures.

the house, folded them as nicely as I could, and sold them to passersby. Some of them were as old as a month. Some of the papers we took were never opened at all, and those were a cinch.

"I was doing very well when my father rudely interrupted my business. He said the neighbors were complaining that I sold them old papers. But I made around three dollars before I got into trouble.

"My next job was working in a cannery during vacation time. I carried boxes of fruit, and did all sorts of odd jobs around the place. I earned about nine dollars a week."

Louise Fazenda

"WHEN I was fourteen, my family met with such financial reverses—though we were never wealthy, heaven knows—that I had to stop school and go to work," says Louise Fazenda.

"I thought it would be fun to work in a candy factory, and so I went to Bishop's and hired myself out. I earned $4.90 a week—no, I don't know why it wasn't an even five—but I soon inquired around as to what work paid the best there, and found out it was the chocolate dippers'. So I applied for that work, and finally mastered it. It is rather a delicate business, and it takes a while to acquire the knack. I earned about twelve dollars a week.

"While I was working there, Mary Pickford came through the factory, and I remember how thrilled I was at her visit. Next day I came to work with my hair in long curls. I bought my first store dress while I was working at Bishop's. I have it yet.

"I always remember the first day I came home from Bishop's. I was all elated over my job, but when I came into the yard, I found my beloved little pet dog which I had had ever since I was seven years old, dying in the front yard. A neighbor's dog had injured him. It was years before I could have another dog."

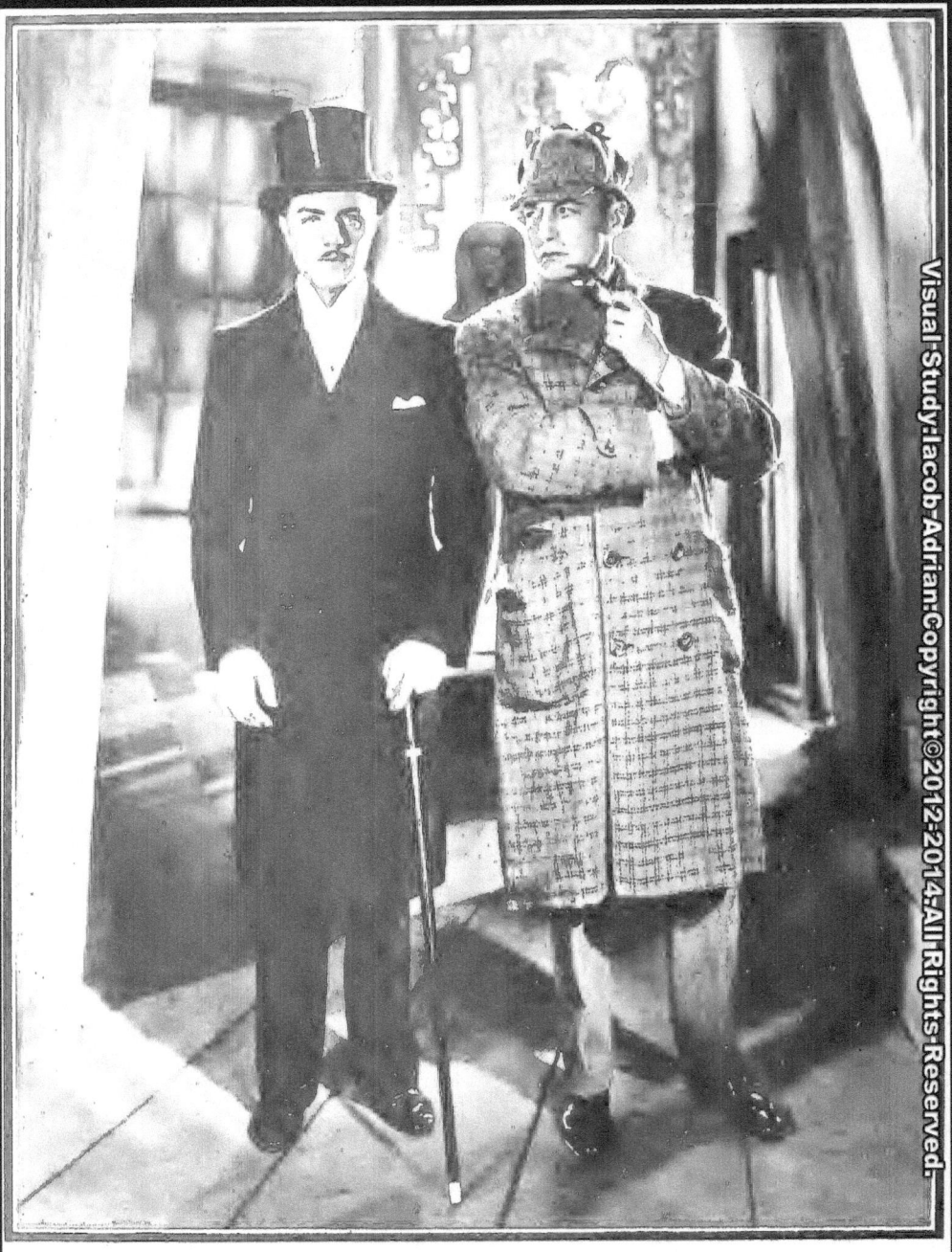

"Mr. HOLMES, MEET MR. VANCE!"

Here you have the old and the new in detectives: Philo Vance, S. S. Van Dine's now famous sleuth as played by William Powell, side by side with Sir Arthur Conan Doyle's Sherlock Holmes, done by Clive Brook. If there is light or heavy detecting to be done, these are the boys to do it. You will see Philo and Sherlock in some amusing moments together in the coming screen revue, "Paramount on Parade."

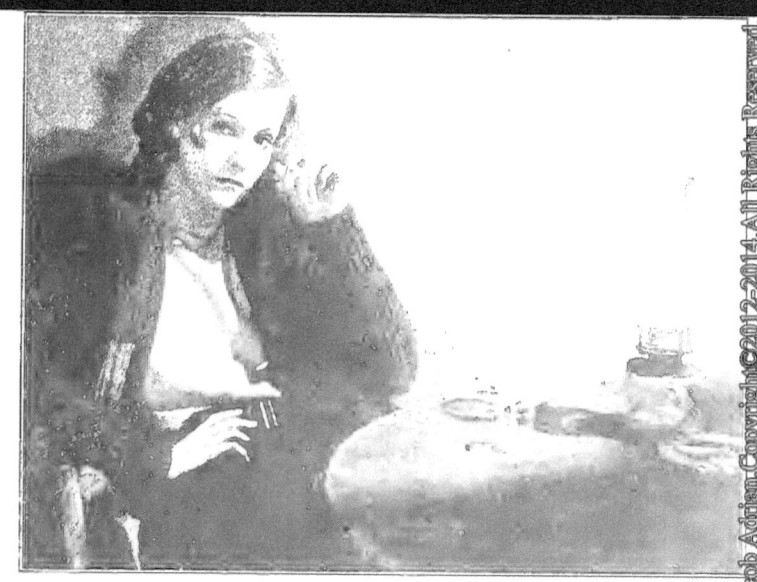

Greta Garbo speaks for the first time in Eugene O'Neill's drama, "Anna Christie," and loses nothing by the vocal revelation. Indeed, with the addition of speech, Miss Garbo is going on to new and greater successes. Be sure to see and hear her—in "Anna Christie."

George Arliss, below, as the Rajah of Rokh in "The Green Goddess." Maybe you saw Mr. Arliss in the silent film version. The talkie is even better. At the lower right, William Powell in "Street of Chance," in which he hits new histrionic heights. His performance of the master gambler is a remarkable one.

The Month's BEST PERFORMANCES

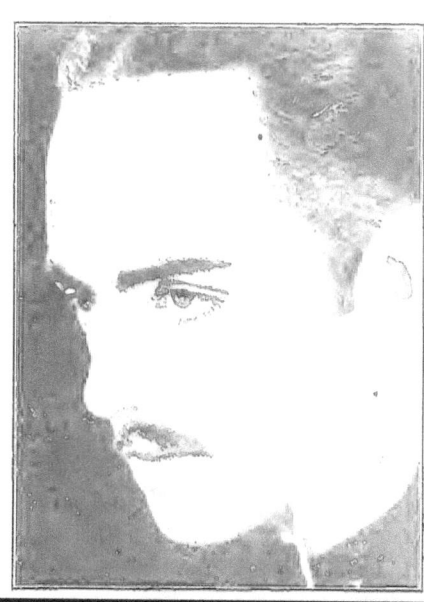

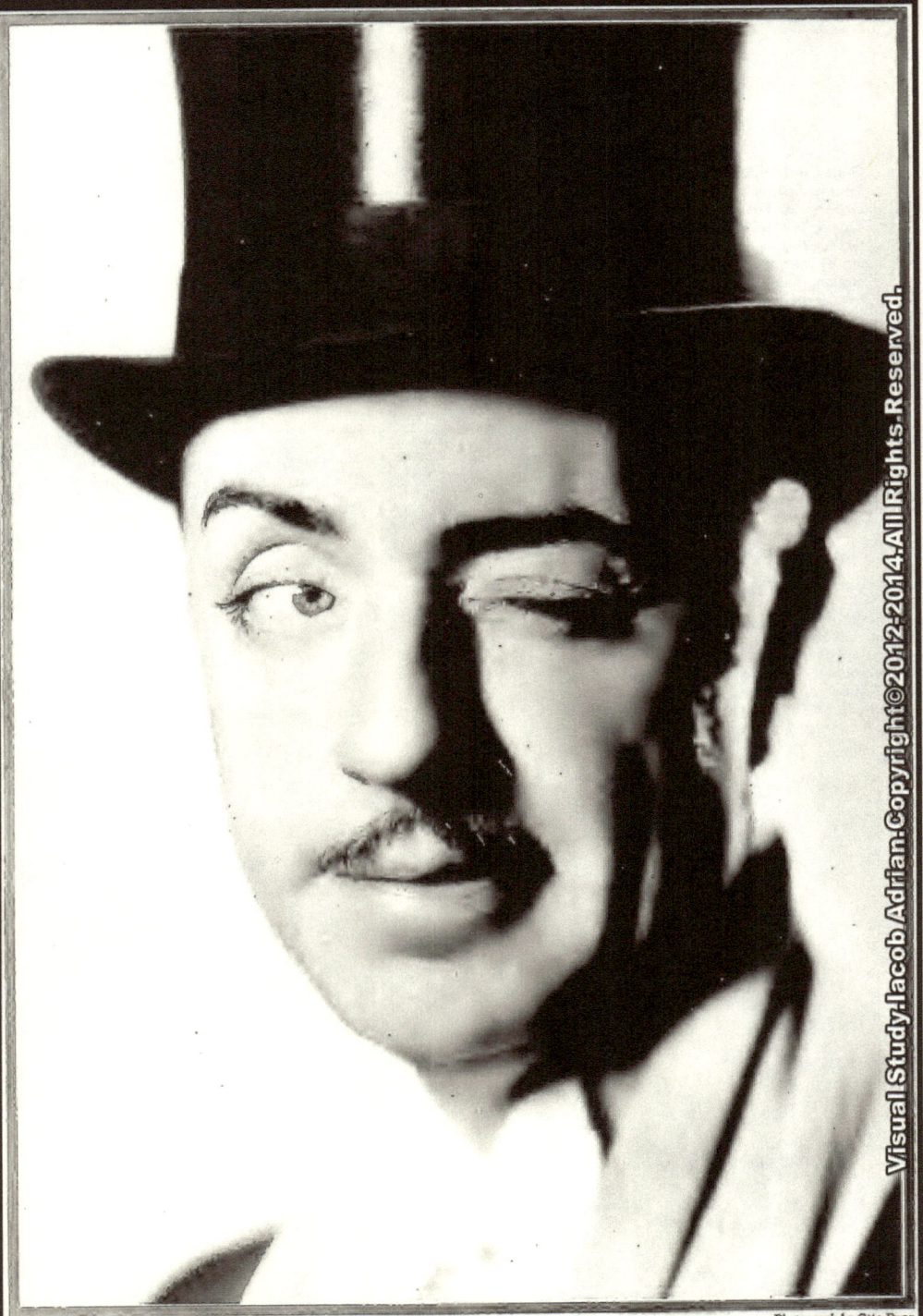

Photograph by Otto Dyar

WILLIAM POWELL

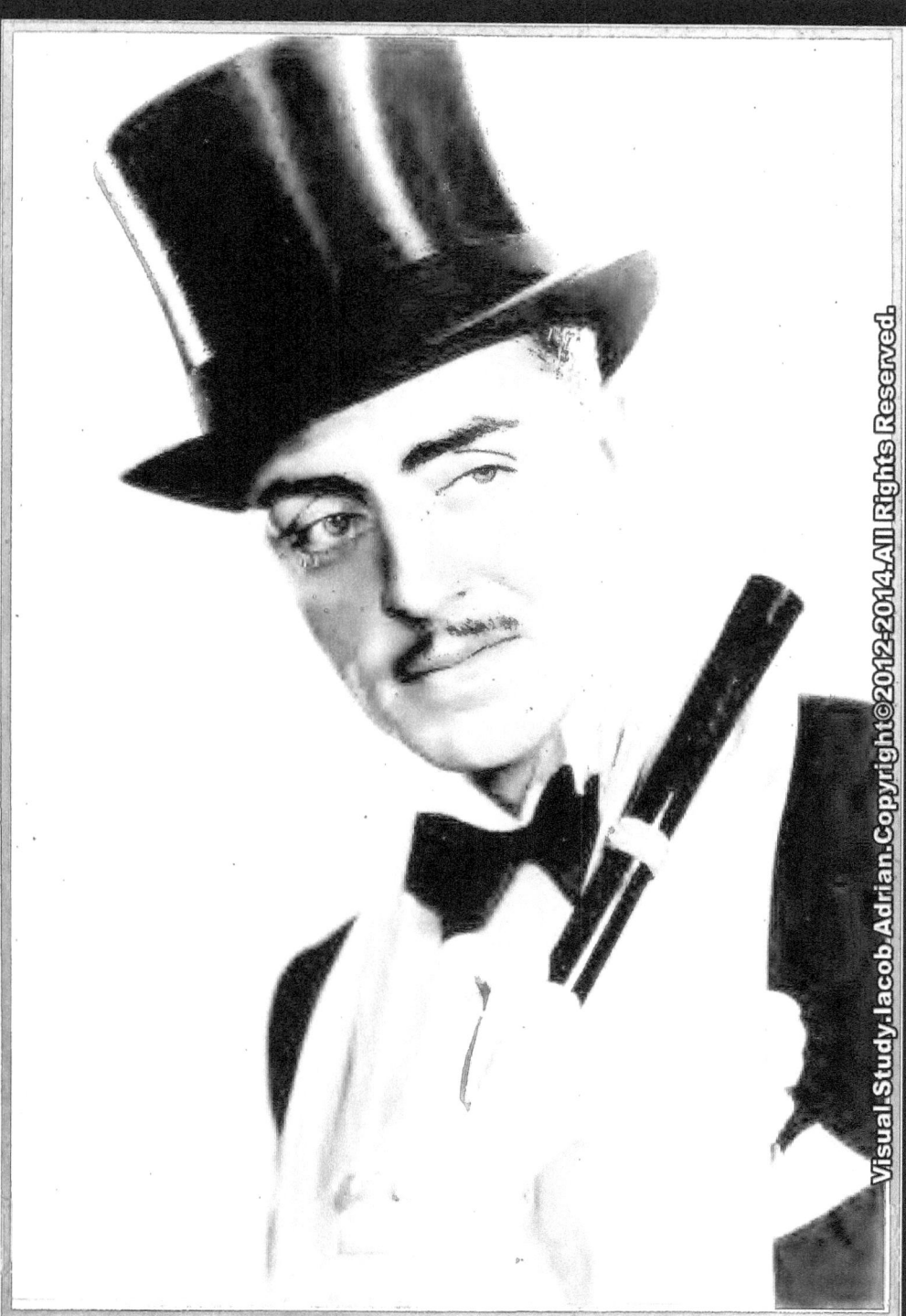

WILLIAM POWELL

Herb Howe Continues His Continental Tour

Well, Charlie, now is your chance. You may be the cinema Napoleon (and I don't mean Elba).

NOT only language is causing difficulty but accent and patois too. A review of "The Big Pond" in a Parisian journal remarks Chevalier's "faubourg" intonation . . . in American we'd call it "bowery." Claudette Colbert on the other hand is commended for her impeccable French. As for the rest of the cast, all American, let us dash down to the Café de Paris and choke our laughter in a mug of something or other.

The Café de Paris: The moon in the sky is a sunkist orange and the orchestra, billed "The Smiling Boys," is playing "Singin' in the Rain." For a moment I'm homesick for Bessie Love and Cocoanut Grove. I'm quickly distracted. Opposite me a girl casts a wistful glance but she's with an old man and her wrists are handcuffed with diamonds. A French girl sits alone but before I can do anything about it an Argentine gigolo canters her off in a tango. A woman with huge arms and lips is erupting Danish. There is a rumble of German gutturals over many beers. And Russian volubility suggests another plot to overthrow the Soviets. My attention is drawn to a table circled by English women. They are joined by two English youths. One says he feels dismal. He objects to the chairs—too hard. He draws up one that seems a bit softer. His name is Bunny. He kisses the hand of Lady Rumblebottom whose high pitched hat resembles the Roman ruins of La Turbie on the hill above. The other two ladies are Mrs. Sqwaunce and Miss Crumblehome. Lady Rumblebottom orders a stinger. . . . She calls it a "Stingah." The garçon misunderstands. . . . He thinks she wants a cigar. The Roman ruins tremble in an earthquake of indignation. Oh, deah, deah, we are all convulsed.

Now fawncy if you can a talkie that would please all these people. Yet after the drinks they will all trickle off to the garden to view the silent "Ben-Hur."

Ben-Hur Wins Again: In the gloom of the talkie situation it is cheering to recall the pessimism over "Ben-Hur." Produced in muddle and squabble with everyone going a bit haywire, this picture cost somewhere between three and four million. A big loss was predicted. Today "Ben-Hur" rates a bread-winner second only to "The Birth of a Nation" with a record of twenty million profit.

"Ben-Hur" is to be re-made with sound. I do not know whether the characters will speak English or original Hebrew. The latter would seem to have more universal appeal. The musical opportunities are magnificent if M.-G.-M. can abstain from introducing a theme song and Ukulele Ike.

In a Paris interview, William Powell aroused to defend the American gangster. "He is not more than 50 per cent to blame," says Mr. Powell. "If he is a supreme product of lawlessness and immorality, it is because America today is lawless and immoral, chiefly as a result of the 18th amendment."

THE English object to the American accent in talkies. You can't blame them when you consider how uncomfortable the English intonations make you. They are aesthetically right, too, if the American actor is playing an Englishman. I wouldn't care for Will Rogers as the Prince of Wales or Ronald Colman playing Will Rogers.

Frederick L. Collins tells of meeting an Englishman here on the Riviera—one of those austere English gentlemen with a beacon nose that indicates a dukedom or at least a lordship.

"I believe we speak the same language," said Mr. Collins affably.

"Not the same," said the beaconed Britisher, "but similar."

Those Yankee Tourists: Before you begin getting an anti-British feeling which so often reduces Americans to the plane of absurdity with anti-American foreigners, let us join a group of charming English girls who speak the language musically (it can be done).

One of them tells a joke:

"One of those American women tourists was being shown about an old English castle. The guide said: 'This part here is twelfth century, this fourteenth century, this fifteenth.' The American woman with a disdainful glance at the ruins snorted, 'Well, thank God we ain't got any centuries in America.'"

Such are the observations that have gone to make the American obnoxious abroad. We are prone to take too much pride in our plumbing. Such American ladies as the one quoted above are to be deplored. They do so much to offset the noble work of Clara Bow in Americanizing the world.

Charlie Chaplin has the Napoleonic complex. Whenever a masque ball offers opportunity he arrays himself as the Little Corporal. Herb Howe says that, if Charlie's new all-silence comedy makes a big hit, it may make him into a real Napoleon.

The Mystery of William Powell

BY EVELYN GRAY

WILLIAM POWELL has played in so many mystery dramas—as a super-crook or the master detective who solves the crime after the police fall down—that we are presenting the picturesque story of his life just as one of his own scenarists would tell it. There really is no mystery to William Powell's success. It's just the result of hard work. Next month NEW MOVIE will tell you more about the suave and interesting Mr. Powell.

WILLIAM POWELL is one of the fortunate men who carved his own destiny.

He wanted to be an actor. He was born to be an actor.

How or why, nobody could figure. There were not any actors in the Powell family. Never had been. No knowledge of nor contact with the theater had ever touched the members of the rather clannish circle.

By all the laws of heredity William Powell should have been a quiet, respectable, orderly business man. By careful training and early environment, he was intended to be a lawyer.

Fervent distaste for routine and time clocks kept him from being the first. A mad, romantic youthful passion destroyed his intentions to be the second.

He fulfilled his own desires. He is the thing he wanted to be —and his family all admit that it has turned out very well indeed.

IN the latter part of July, 1892, a little house on Pittsburgh's north side began to show signs of unusual activity. Neighbors noticed a lady arrive in a carriage. Another appeared on foot. Soon another carriage, with more well-gowned ladies, arrived. Wicker suitcases of amazing proportions were carried in.

All along the street lace curtains were pushed back. Curious eyes peeped out, taking in these unusual occurrences.

"Nettie Powell must be going to have her baby," said one housewife to another. "I see her mother and sisters have come."

In those days, women had their babies at home. Hospitals, baby wards, obstetricians would have been regarded with scorn, not to say suspicion. The family doctor officiated, with the family in eager attendance. A cup of tea instead of a can of ether was administered for comfort.

YOUNG Powell was late for his first entrance. He held up production for days, even weeks. The neighbors watched eagerly. Nothing happened. The star performer was still delaying matters.

Then early one morning Nettie's husband, Horatio, dashed out of the house minus his collar and returned in a few minutes, nervously hurrying another man who carried a little black bag.

In the afternoon, the door of the little house crashed open again. Pa Powell skipped down the walk and headed for a corner several blocks away. He pushed open a pair of swinging doors and cried, "It's a boy, boys, it's a boy. Seven and a half pounds. Mother doing fine. They're on me. Set 'em up for everybody."

In good Dutch beer, the gang toasted the newcomer.

"What's his name?" they inquired.

William Powell, at the age of seven. The year was 1899, just after the Spanish-American War. Bill's proud parents were painting a legal career for their offspring. Below, Bill's father and mother, Horatio and Nettie Powell, who now live in Hollywood with their son.

He Came From a Family Untouched by the Theater and He Was Destined for the Law —But He Became an Actor

"William," said Horatio Powell. "William Powell, after his grandfather."

"Here's to William Powell," said the friends and hoisted steins.

WILLIAM POWELL has been toasted since then many times in many lands. But never in better beer nor with more honest good wishes. Because Horatio and Nettie Powell were very popular in Pittsburgh. Fine young couple. Doing well. The right kind of American citizens.

"You want to know where Will got his acting trend?" said Father Powell to me. "Look at his mother. What an actress she would have made. Never had a chance to do it, of course, but I don't believe there's anyone on the stage would have made a better comedienne. She had it in her."

Bill's handsome, gracious, white-haired mother blushed a little, but there was a twinkle in her eye. Certainly there is no question as to where the hero of "Street of Chance" and "For the Defense" got his distinguished good looks.

Many people imagine that William Powell has a foreign look. His first big stage success, his first big picture rôles, were all in foreign parts —Spanish, Italian, Cuban. As a matter of fact, he is American to the core. Perhaps that look is his heritage from a paternal grandfather named Brady. The black Irish fit into any nationality. There is, too, a good strong strain of Holland Dutch, and a bit of French and English. But to know Bill well is to realize that once again the Irish predominates over all other ancestry.

THE first thing this baby did to distinguish himself from all the other babies of Pittsburgh was to sit up in his crib at the age of five months, wag his right forefinger at his admiring parents and remark, "I umpha basha arga." Not once, but many times he did it. Long before he could talk in any accepted terms, Powell, junior, made speeches from his crib and highchair. There was no question that they were intended to be speeches, because they were accompanied by gestures and a noble, intent expression.

"I umpha basha arga" became a tradition in the Powell family.

"I have made speeches since that were less coherent," said Bill, with the slightly sheepish look that comes over all men when their infant days are highlighted by the older generation.

After watching him for some time, Mrs. Powell said breathlessly to her husband, "I'm sure he's going to be a preacher."

Father Powell demurred. Billy Sunday hadn't yet pointed the way to millions through the

Many fans believe that William Powell is of foreign birth. He was born in 1892 in Pittsburgh. Irish ancestry predominates all others with Bill Powell, although in him there is a strain of Holland Dutch and a bit of French and English as well.

HOW BILL POWELL, PITTSBURGH BOY, MADE GOOD

ministry and Bill's father had the American ambition to see his son in something that would be profitable as well as successful.

"He's going to be a lawyer," he said. "Look at the way he uses that forefinger."

For eighteen years, Horatio Powell cherished the delusion that he was the father of a lawyer.

He might have been, if it hadn't been for a girl named Edith. Why is it that there is always an Edith in every man's life? The first girl—the dream girl of adolescence?

IF Bill hadn't fallen in love with Edith in high school in Kansas City he might now be playing "For the Defense" in real courtrooms instead of those built by stage carpenters.

He doesn't think he would have been happy. Acting was the one thing he ever really wanted to do.

Right from the beginning, young Bill showed a trait that has never left him. His passion for conversation with men—all kinds, anytime, anywhere. He and Ronald Colman—you must know that they are inseparable friends—talk an entire week-end away in Ronny's cottage at Malibu.

His close friendship with Dick Barthelmess began with a conversation that lasted three days.

One of his first pictures was "The Bright Shawl," with Barthelmess. Neither one was pleased about the casting. Powell thought Barthelmess was just another star. Barthelmess thought likewise that Powell was just another actor.

On the boat bound for Havana, they ignored each other pointedly for twenty-four hours. Passing on deck, they didn't speak. Inwardly, Powell said to himself, "Ham." Inwardly, Barthelmess said, "Ham." Finally, they bumped each other smartly coming around a corner.

"G-rrr-rr," said Barthelmess.
"Same to you," said Powell.
"Well," said one, glaring bitterly.
"Well," returned the other.
"Do you drink?" said Barthelmess.
"Yes," said Powell.
"Come on."

Without more ado they repaired to the star's stateroom and didn't come out for three days. They talked for twenty-four hours without sleeping, and they've been pals ever since.

IN his youth, Bill's hobby was street care conductors and blacksmiths.

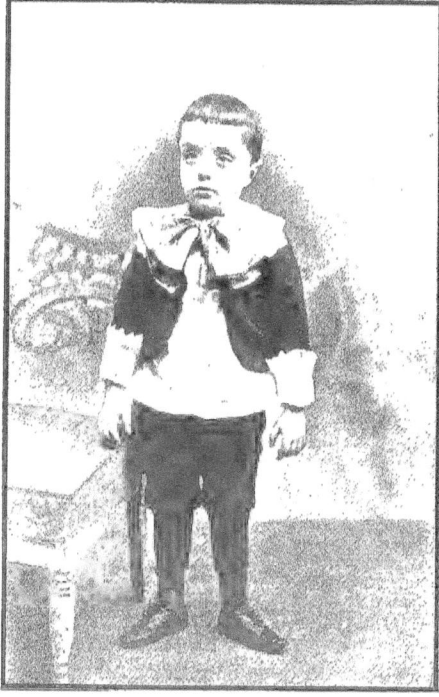

Another early portrait of William Powell, this time at the age of four. At this time Bill's hobby was street-car conductors and blacksmiths. Bill usually visited the neighborhood smithy, borrowed a nickel and spent the day touring Pittsburgh by trolley.

He was a slim, sturdy little youngster with startlingly blue eyes. With serious mien, he would walk quietly out the backdoor and disappear. Later, Mother Powell would be seen running around the block looking for her offspring. Horatio Powell, coming home from his accounting offices, would take up the search. He soon developed a system. His first stop was at the blacksmith shop, three blocks away.

"Seen anything of Will today?" he'd ask the brawny man, busy at his glowing forge.

"Sure. He was in here for a couple of hours early this afternoon. We had a long gab about why horses have four legs and humans have only got two. That feller can ask more questions than any kid I ever saw."

"Where'd he go?"

"I dunno. He borrowed a nickel off me and skidaddled."

That nickel was the clue. Nickels meant street cars to Will. He would finally be discovered deep in discussions with the motorman or the conductor upon whose car he had made six round trips with that nickel. Nothing could break him of this habit. Besides, he was so intent upon gaining information that his parents didn't have the heart to punish him. He was getting an education of sorts.

Incidentally, Bill Powell never felt the stern hand of parental discipline. Never as a child was his little spank spanked.

His mother says it wasn't necessary. She employed more subtle and more effective methods.

BY the way, I don't mind telling you now that William Powell's mother thinks pretty highly of him. After thirty-eight years of intimate acquaintance, she will contend he's the best man she knows—except his father. The three of them live together, which shows real love and understanding. Bill is the sort of bird who likes liberty and would quickly resent any curtailing of his privileges. Their apartment in Hollywood is charmingly arranged, run for Bill's convenience, and his complete comfort.

This looks a little more like the William Powell of Hollywood triumphs. Bill is eleven and an earnest student, even a "teacher's pet." Young Master Powell was then looking forward to a great career as a lawyer.

Here's an attractive item for the beach next Summer. Bebe Daniels offers her idea of a bathing suit that can be transformed into beach pajamas. At the left, Miss Daniels shows her simple, one-piece, backless suit of white jersey. This is ideal for real swimming. Second, she fastens part of the pajamas around her waist like a train. The material is heavy flat crepe, dyed several shades of gray in a batik design, and painted with rose fish and sea urchins. In the third picture, the pajamas begin to assume form. The front overlaps with the back and ties with a large bow, while the sides remain open to permit of easy movement. Fourth, the pajamas are complete.

The Mystery of William Powell

"It wasn't ever necessary to punish Will," said Mrs. Powell. "It wouldn't have done any good anyway. You had to reason with him. He was very obedient, if he understood a thing. But you had to explain all the whys and wherefores. Then, if it looked logical to him, he would do it without any trouble. If it didn't he'd convince you you were wrong. That was another reason I thought he'd make a good lawyer. He was so reasonable."

She heaved a little sigh. Even now that her son is one of the great movie stars, I think Mrs. Powell remembers her dreams of seeing him administer justice from the bench.

It seems to me that Bill has run true to form in all the predictions of his childhood. His character fundamentals are about the same.

"There was one thing about Will that was different from most other children I have seen," said Mrs. Powell. "He could always amuse himself."

Give him a box of blocks when he was quite small and he was good for a whole morning. He didn't want anyone else to build houses or arrange them for him. In fact, he rather resented interference. Apparently he had ideas of his own that must be carried out. He was never depending on anyone else in order to be happy and well occupied. Later pencil and paper, books and pictures took the place of blocks.

WILLIAM POWELL is still like that. He doesn't mind being alone. If he has enough books, he is perfectly happy and contented. Not all the time, of course. He likes a bit of whoopee as well as the next man, and is a most convivial and entertaining companion. But he is a real book lover. When he comes into my library at Malibu, he touches the volumes gently, examines the bindings, picks out a few and peeps into them, reading a paragraph or two. Also, he is one of the few people who borrow books who always return them.

This summer I saw him stretched out in the sun, hour after hour, alone, with a big stack of books piled on a table beside him. They were never allowed to touch the sand.

"Was he always careful of books as he is now? I asked his mother.

"Oh, yes," she said. "I remember how he cried one time when a book he liked and had read a dozen times was chewed up by a neighbor's dog. He took wonderful care of his books. But then, he took wonderful care of all his things. His room was always neat, his clothes always hung up where they belonged. He folded his pajamas every morning. He could never be happy if anything was in disorder around him. So different from my grandson, Bill's little boy."

Baseball and sand lot football interested Bill Powell in his grammar-school days. But athletics never became a strong passion with him. He liked talk, reading, people too much. Athletics seemed slightly a waste of time. His friends were usually older boys who were too big for him to play with but not too smart for him to talk to.

IT is an awful thing to admit, and I will say in all fairness that he shows no signs of it now, but in school Will was "teacher's pet."

His first battles were fought at school because the boys used to call him that in a manner not too polite.

"I was in a tough spot and didn't know it," he told me. "I made companions of my teachers and profs because I liked them. They always talked about things that were interesting. I wasn't trying to ease myself into their good graces in order to get better marks in school. In fact, I flunked several courses in high school even though the profs were my pals. I just liked to hear them talk."

When the Powell family left Pittsburg for Kansas City, Bill was ready to enter high school. Professor Smith, of the 6th Ward School, Pittsburgh, wrote a letter to the teachers who would

take him in charge in the new school. His mother still treasures that letter. In it, Professor Smith recommended Bill to the special attention of his high school teachers as a boy of unusually brilliant mind and active brain. It wasn't his conduct which was acclaimed, but his eager mental ability.

There is an unsolved mystery connected with another memento which reposes in that cedar chest. It is a shaving mirror—Bill's first gift to his father. On it is written—From Will. Xmas, 1901. The mirror was on the Christmas tree. No one knew where Bill earned the money to buy it. No one knows to this day. When I questioned him, Bill began to talk about the Einstein theory.

Maybe that's a skeleton in Bill's youthful closet.

ALL his vacations were spent on his grandmother's farm, in West Middlesex, Pennsylvania. Upon his arrival, the farm was turned over to this favorite grandson, by a grandmother devoted to her husband's namesake. Through the farm ran a little stream, with many deep pools. The boy swam, dived, ran wild for the entire summer. It built up his health, which was not too robust. And he spent long afternoon hours swinging in the hammock, singing to himself, and reading. Ideal days. Every kid should have some experience in the country.

William Powell graduated from grammar school when he was thirteen.

At fourteen, he entered the Kansas City High School.

For four years, he was a "leading citizen" of that institution. He wrote for and edited the school paper and annuals. He was yell leader at one time and sang in the glee club. He took part in all the school activities and held various offices.

Ralph Barton, now famous all over the world for his drawings, was in High School at that same time. He was the paper's cartoonist for three years. When he left, it was a bitter blow to the artistic triumphs of the sheet. In desperation, Bill decided he could draw cartoons. And did. They weren't as good as Barton's, but they got by all right.

Because he was going to be a lawyer —that having been decided in his cradle and planned for every hour since —Bill took some high school course in public speaking. It was a subject he loved and in which he did remarkably well. His speaking voice was unusual, he had a dramatic flair for intriguing and holding his audiences.

The professor suggested immediately that he ought to try out for the school play, which was the big event of the year, held just before the Christmas vacation.

IN his junior and senior years, William Powell played the lead in those plays. Played them, so everyone tells me, remarkably well. A natural-born actor.

Right there, everything was settled. That was what he wanted to do. Acting was his real ambition. There was something he would like to do.

Also, acting was a quick road to fame and fortune. He saw himself taking New York by storm, rising to heights of greatness, thrilling vast audiences who applauded his genius and showered him with rich rewards.

Though he had never been backstage of a theater, knew no actors, had no connections of any kind with the stage life, he felt that he must and could succeed.

To be a lawyer meant four long years at Kansas University, where he was about to be enrolled. Two or three more for a law degree. He'd be an old man before he was allowed to practice!

Whereas it was strictly necessary for him to be able to support a wife in the shortest possible time. Why, he and Edith had been waiting now, ever since their sophomore year! They had

The blackboard with its K tells the story. The two Kays—Kay Francis and Kay Johnson— are both featured in William De Mille's new Metro-Goldwyn film, "The Passion Flower."

The Mystery of William Powell

been in love for what seemed centuries.

Edith was a pretty, blond girl, and she was Bill's first love. It was serious, right from the start. No playing around. They "went together" for four entire years of high school, and when William graduated considered themselves officially engaged. He was eighteen. She was sixteen.

These things young Powell pondered deeply during the summer vacation after his graduation, with honors, from High School.

WORKING in the clerical department of the Kansas City Telephone Company, Bill thought deeply.

With a bitter loathing, he hated his work at a desk. Everything in him rebelled, not placidly, but actively and violently, against regular hours, routine work, the same faces, same surroundings day after day. If he went to college, he'd have to work there summers. He'd have to spend the best years of his life slaving to learn law. And he didn't want to learn law. He wanted to act.

One year in New York, he'd be a success, and he and Edith could marry.

So he decided to write to his Aunt. She was really his great aunt. A very, very rich great aunt. The matriarch of the Powell family.

But Bill knew that already the family had made many drains upon her. Already she had financed many a Powell project.

He was different. And he sat down and composed a twenty-three page letter to prove to her that he was the flower of the Powell family, clean, honest, hard working. He tried to impress upon her the fact that she would be denying the American theater a great genius if she didn't send Bill money enough to go to New York. The letter was a masterpiece.

It asked for money to pay a year's tuition at the Sargent School of Dramatic Art, and fifty dollars a month for that year. Within five years, William Powell would return to her that money with interest. And she would forever be glad and proud that she had helped him to attain great heights in dramatic art and bring glory and renown to the name of Powell.

He read the letter to his mother. He read it to Edith.

Then, with prayer and trembling, he put a stamp on it, dropped it in the mail box, and sat down at his desk in the telephone company to await the answer which, to his youthful vision, meant life or death, happiness or despair.

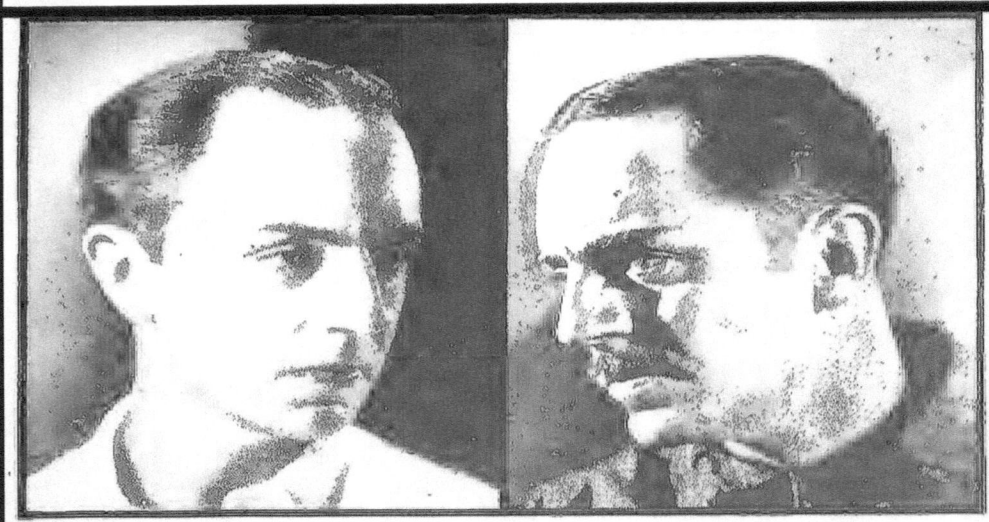

Girls, Bill Powell has shaved off his mustache! Look above, at the left. You will see Powell, sans mustache, in "Facing the Law." At the right, the last appearance of Bill's mustache, in "The City of Silent Men." The mustache was exactly five years old at its demise.

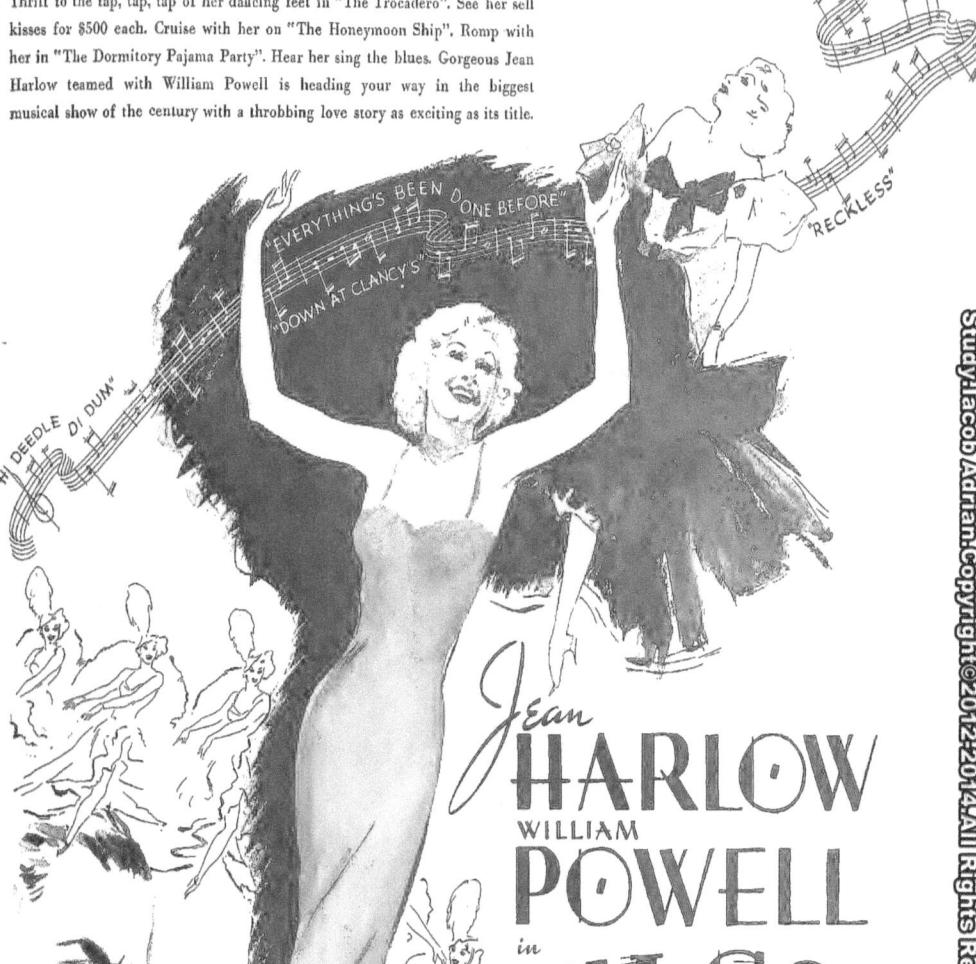

Mystery of William

William Powell says that he owes a great deal to the late Leo Dietrichstein, the distinguished stage actor in whose company he played for some seasons.

BY EVELYN GRAY

A WEEK passed.
Young William Powell added figures, wrote statements and interviewed customers in the office of the Kansas City Telephone Company, and awaited an answer to the all-important letter he had written to his great-aunt in Sharon, Pennsylvania.

His mind wasn't on his work. He couldn't think about the prosaic and endlessly monotonous business before him. His brain hummed around a million questions.

Would the rich old matriarch of the Powell family send him the money to go to New York and study for the stage or would she not? Must he continue a galley slave to a business he loathed, or would she wave a magic wand and open the gates to a golden future where he could pursue the career of an actor now so dear to his heart? Would he have to wait years and years to marry his pretty high-school sweetheart, Edith, or would his aunt make it possible for him to go to New York and achieve fame and fortune overnight, so that he might dash back and claim his bride?

His fate trembled in the balance of the old lady's will, for he was only nineteen and he knew that without her help he dared not, his parents would never allow him to venture New York alone.

Then one afternoon the telephone rang.

"Will," said his mother's voice, "there's a letter here for you from Sharon, Pennsylvania."

"What does it say," demanded Bill.

"I don't know," said his mother, "I didn't open it."

"For the love of Pete," yelled Bill, "open it quick."

He waited, his heart doing flipflops.

"It's signed Quincy Adams Gordon," said the voice at the other end of the wire. "He's aunt's lawyer."

Bill's heart sank. A lawyer. That meant that he was to be told in no mean fashion that aunt was through with helping aspiring members of her family who never paid her back.

"He says she will pay your tuition for a year at the Academy of Dramatic Arts in New York and give you fifty dollars a month to live

THERE is no mystery to William Powell's success. It came by hard work.

Mr. Powell was born in Pittsburg late in July, 1892. The baby was named after his grandfather. Despite his south-of-Europe appearance, Mr. Powell's ancestry is almost entirely Irish, with a touch of Holland Dutch.

The Powells moved to Kansas City and Bill attracted attention in high school dramatics. That shaped his career. After graduation, he worked in the clerical department of the Kansas City Telephone Company. But he longed for a stage career and, hoping to get enough money for his tuition at the Sargent School of Dramatic Arts in New York City, he wrote a letter, outlining his hopes, to his wealthy great-aunt.

William Powell, at the age of fourteen, and a school pal named Fletcher Street. Bill is wearing a snappy pair of shorts, as you will note.

POWELL

How the Popular Actor Gained His Dramatic Training, How He Won the Help of Leo Dietrichstein and How He Came to Motion Pictures

on," said his mother. "William — William don't you hear me?"

THERE was no answer. William Powell was in telling his boss what he could do with his job. He didn't even wait to finish the day's work. In an hour he was home, packing.

Tearful farewells to be said. His father and mother trembled, as they saw their beloved only son venturing into a new world, a world of which they had heard so much that was evil. They saw him starting on a path which fact and fiction agreed was fraught with temptations. They had never discouraged him, but he was the first of the family anywhere to enter a theater save through the front door and they were both amazed and fearful. But they believed in him absolutely. Soon he would rival Mansfield.

He had to say good-by to Edith, too. The girl who for four years, all through high school, had been his ideal and his sweetheart. They were now definitely engaged. He was only twenty. She was still in her teens. But they were so sure that family opposition to such a young engagement was withdrawn. It wasn't puppy love. It was the real thing.

And Edith, with tears in her blue eyes, waved good-by to her man as he started out to conquer the world for her sake.

Nothing happened as they had planned it, but fortunately they didn't see into the future.

The Academy of Dramatic Arts of New York was then in Carnegie Hall. Bill got a cheap room near there, enrolled in the necessary classes and went to work.

Fifty dollars a month in those days was a lot more money than it is now. Bill didn't live in gilded luxury. He didn't cut any wide swath in the night life of New York. But he managed to do himself fairly well. He had a place to sleep, enough to wear, and at least two square meals a day. No week went by without a big box from his mother in Kansas City.

THE work at the school was just what he wanted. It was practical training, which would get him to the place where he could go into the theater.

But above all, he loved New York. New York was a big city, and it teemed with life, with drama, with color. Not one soul in the millions who filled the streets did he know. Yet he was never lonely. For he made friends with New York itself. He loved to wander on Broadway after the lights were lit. He loved to mingle with the crowd and watch their faces and try to picture to himself how they lived and where, what problems they faced of love and work and living.

He bought himself a second-hand edition of O. Henry and read avidly that great writer's tales of the Four Million. All around he searched for such adventures — and sometimes found them. Central Park was beautiful. Fifth Avenue was the finest street in the world. The Bowery, the Metropolitan Museum, the Ghetto — everything was new and wonderful.

"That was real education," Bill told me. "In some ways maybe it was better education than I could have obtained in four years at college. I came to know people, their expressions, their ways of moving and dressing, their reactions. I used to stand around staring and listening until it's a

William Powell in his first dress suit. He wore this when he took part in his first play, "An American Citizen," given by the senior class of the Central High School of Kansas City. Bill played the leading role in this play.

wonder I didn't get shot. I never thought about that. To me, it was a panorama being staged especially for my benefit."

There is still much of that observer in William Powell. There is more of the observer in his attitude toward life than anything else. He loves life, but not much of it gets very close to him. He stands back — and watches.

At the end of his first term at school, he decided he had had enough instruction and that he'd better go to work. More could be learned by actual experience. Besides, he was terribly impatient. He wanted to get about the business of becoming a great star. Fortunately, because during those waiting years he worked hard and learned important and necessary things. It never occurred to young Powell while he went through the hard grind of stock and road companies, while he fretted and raged that he didn't get his chance, that he was preparing for a day when a new art called "the talkies" should bring

him wider fame and greater returns than he had ever dreamed.

AS soon as he went to work his aunt's support was withdrawn. But he paid her back every cent she had advanced him, with interest at six percent.

Perhaps he wasn't entirely disinterested in that. Sometimes the money came mighty hard, and after all, she had so much. Still, he had an idea in the back of his head. He was her nephew. If he proved to her how honorable and reliable and hard-working he was, he might become her favorite nephew. He had visions in his hall bedroom of the day when the dear old lady should pass to her reward and Quincy Adams Gordon would send for William Powell.

"My boy," he would say, "you didn't know your dear aunt well. But she watched your progress with great admiration. She appreciated your high standards and your honesty. She never forgot you paid her back the money she advanced you, and with interest, at that. Of all those she helped in life, you were the only one who repaid her fairly. So now, she has made you her sole heir."

Such were young Powell's dreams, as he saved his pennies and sent off money orders to Sharon, Pennsylvania.

They didn't come true. When she died, aunt left her money to found a home for aged and indigent Protestant clergymen.

His first job on the stage was in Rex Beach's "The Ne'er-Do-Well." He played four parts, most of them with beards. It was a second company, playing around New York City. Bill didn't get much of a chance to show what he could do, but he received a salary and the experience.

UNTIL 1921, William Powell worked a slow and gradual and sometimes discouraging way upward in the American Theater. He played stock in Pittsburgh, Detroit, Portland (Oregon), Boston, Buffalo and Northampton. He toured with first, second and third road companies. He played small parts and character parts in New York. He played leads, old gentlemen, heavies, juveniles, and characters. For ten years he kept at it, working steadily but seemingly getting nowhere.

Two great experiences happened during those slow, invaluable years of training.

In the road company of "Within the Law," in which he was playing English Eddie, he met a young actress named Aileen Wil-

In the oval above, William Powell is shown at the very moment of graduation from the Central High School of Kansas City. Below, Bill Powell, when he was a member of the Northampton Players, the municipal stock company of Ex-President Calvin Coolidge's home town. Bill was 23.

son. She was young and talented. She was as deeply interested in the things of the theater as he was. She belonged to the new world into which he had stepped.

With her coming, he realized that he no longer loved Edith.

Little by little, Edith's image had dimmed. The engagement had dragged on, meaning less and less. He couldn't picture her in the new life he was living. He knew things were tough for an actor's wife—on the road, moving from town to town, working nights. Separation, new interests, maturity, had gradually overcome the boy-and-girl love he had felt for Edith.

So, when he was playing in a town near Kansas City, William Powell journeyed to see the girl he had left behind him. Their letters had grown fewer, shorter, less affectionate month by month. But nothing definite had been done.

On the way, Bill Powell tried to figure out what was the honorable thing to do. Surely it wasn't right to marry the girl if he no longer loved her. Surely it wasn't right to go through with the thing when it meant unhappiness for both of them. Yet how tell her all that? How could an honorable man break with a girl to whom he was bound by his word?

THEY met. They started to talk. They started to say the same things. For Edith didn't want to venture on the hazardous career of an actor. There was a very nice young business man in Kansas City, who was doing well, and her father and mother thought——

Bill said he thought she was right—and departed. He was free to tell Aileen that he loved her.

On April 15, 1915, at Mount Vernon, New York, William Powell and Aileen Wilson were married.

The marriage was not destined to last, but it began happily enough. They were very much in love. But it was typically a theatrical marriage. Both went on with their careers. When possible, they got engagements together. When that couldn't be done, they were separated for long periods. There was very little home life possible. Still, in the beginning they were romantically thrilled with life and with each other.

The other important thing which happened before 1921—the year which fate had destined to change William Powell's fortunes—was his meeting with Leo Dietrichstein and his engagement to play in "The Great Lover" with him.

Dietrichstein was at that time one of the distinguished stars of the New York

Mystery of William Powell

stage. But he was more than popular. He was an actor who loved his work with an absorbing passion. To him, acting was a major art. He was an Austrian, temperamental, suave, worldly.

From the start, he took a great interest in William Powell.

"The interest," Bill told me, "manifested itself in bawling the dickens out of me. Never, before or since, has anyone had such beautiful, all-embracing tongue lashings as Dietrichstein gave me. He would call me into his dressing room and sit looking at me, as though I were some strange animal out of a zoo. Then he would begin, delicately, with polished sarcasm and a nice choice of invective, to tell me just how rotten I was. He would explain in the most minute detail how bad my performance was, how I missed every good point, destroyed every possibility.

"At first, I expected to get my notice daily. But soon I realized that I was the only member of the company to whom he ever paid any attention. When he had finished combing me over, he'd invite me out to supper and over our beer and boloney he'd give me inspired lectures on the art of acting.

"'ACTING' he would say, 'is both an interpretative and a creative art. It must have depth, sincerity and technique. A great composer may have symphonies in his head greater than those of Beethoven. But he must know how to express them before they can reach the ears of the world. So with acting. First, there is the depth, the understanding of life, people, character. Then, sincerity—to believe in your work. Next technique. The knowledge of how to convey to your audience what is in your mind and heart.'

"He taught me more about acting than I have ever learned in all the rest of my experience put together. If I've ever given a good performance, I owe more of it to Leo Dietrichstein than anything else. I know he believed I had possibilities, or he wouldn't have bothered to correct me. So I began to hope and not get discouraged, realizing all the time I was laying up capital which would some day bring me returns."

In 1921, William Powell appeared on Broadway in a play called "Spanish Love."

The play was a hit, Powell was a sensation. As the romantic bad man, who in the end sacrificed himself to the happiness of the girl he loved, Bill literally knocked New York cold.

"It was great luck for me, getting that part," said Bill.

Probably it was. But when opportunity knocked, he was ready. The critics applauded him with many adjectives. The audiences cheered him. He became a New York success—ten years after he left Kansas City with that as his goal.

His first picture was "Sherlock Holmes," for which he was selected by Albert Parker, a director who had seen him on the stage. Then, between stage engagements, he did such productions as "When Knighthood was in Flower," "Romola," "The Bright Shawl," "Under the Red Robe" and others.

It was while he was making "Romola" in Italy with Lillian Gish, that he met Ronald Colman and formed the great friendship which has made them inseparable companions ever since. They are opposites in many ways. Ronny, the quiet, self-contained Englishman, ruled always by his head. Bill Powell, fiery, temperamental, emotional in everything he does. Yet they make a great team. They are always together. They're working out a scheme now, whereby they can work part of the year and spend the rest traveling or living for a few months in Italy or England or France, for the almost essential change from Hollywood.

At first, pictures were a secondary matter to Bill. A mere chance to add a few dollars to his income. He regarded them as an illegitimate child of the stage.

But as he began to get more and more engagements, he thought the matter over carefully and decided to go west and make the movies his main business. He knew well how uncertain the theatrical business is and how small the chance for even the most popular star to build up a solid competence. He never expected to be a picture star, but he was in great demand for heavies and characters and foreign rôles and he believed in the end it would give him a better chance. Besides, his two great friends, Ronald Colman and Dick Barthelmess, both lived in Hollywood and he'd have more fun out there.

To Hollywood he finally went, in 1925.

There was another reason for his change of base.

He and his wife had come to a final parting of the ways.

Nothing especially disastrous or dramatic had happened. Their unhappiness was more difficult because there was nothing to explain it nor to fight against. Simply, he and Aileen Wilson didn't agree about anything under the sun, moon and stars. They got on each other's nerves. They quarreled, and bitterness grew. They were separated for long periods. Then came together again, to find that they didn't belong together.

IN February, 1925, when they had been married for ten years, their first and only child was born, a second William Powell.

Oddly enough, instead of bringing them together, this event separated them for good and all. They made a thoughtful and perhaps a wise decision. In their hearts, they knew that their marriage was doomed. It seemed foolish to go on with a relationship that brought neither of them happiness. They agreed that it was better to part before the child was old enough to realize the change, or before he was old enough to sense the lack of harmony in the home.

So they parted. Mrs. Powell obtained a divorce in California about a year ago. She lives quietly in Hollywood with her son, who is one of the brightest and most attractive kids you ever saw. She and her ex-husband are friendly. And big Bill is devoted heart and soul to little Bill. They spend week-ends and Sundays together. They go on trips. Little Bill comes to the big gay apartment where his daddy and his grandfather and grandmother live and passes many happy hours.

Bill isn't a recluse nor an alleged woman-hater like Ronald Colman. He adores women, loves gay companionship, likes to laugh and dance and have a grand time. But, at present at least, there isn't any serious entanglement. William Powell's name isn't connected with that of any woman.

After he came to Hollywood, Powell found himself in real demand. He scored a success with Richard Dix in "Too Many Kisses." Soon Paramount put him under contract. In "Beau Geste" he did a great piece of ch ˒cter work. Repeated in "Senorita" with Bebe Daniels, "Beau Sabreur" and "The Last Command."

Slowly, he built up a following and gained a reputation as one of the best actors on the screen. A good many times he stole the show from the star. But he wasn't the type of which silent day stars were made, and it looked as though he had reached his limits, and would continue as a featured member of casts, playing unusual characters.

THEN came that great era of talking pictures.

Foundations shook and the heavens of Hollywood reeled. Some went up, some went down.

William Powell, the disciple of Leo Dietrichstein, the graduate of ten years of stock, road and Broadway stage experience, shot upward in a manner unexpected to everybody. His delightful speaking voice took to the microphone as a woman takes to flattery. The new technique of the talkies approximated the stage technique which he had learned so carefully. More, with the advent of sound, the types of stories and of personalities changed.

I still think "Street of Chance," in which he played a rôle written around Rothstein, the New York gambler, ranks as one of the best talkies yet produced.

As he earned solid success on the stage, by work and ability, so William Powell has, more than any other actor perhaps, earned movie stardom by consistent build-up, and for that reason he'll probably stay a long time in his present position. At that, he would make a great director.

Meantime, he lives very quietly with his father and mother. Is a very wordly, charming, slightly cynical person, with a touch of the whimsical that is always unexpected. His love for books has grown with the years. He plays tennis, likes the ocean and loves to travel better than anything else.

Altogether, a real American in spite of his foreign appearance, a grand actor and without exception the most delightful companion I can think of.

Photograph by Otto Dyar

WILLIAM POWELL

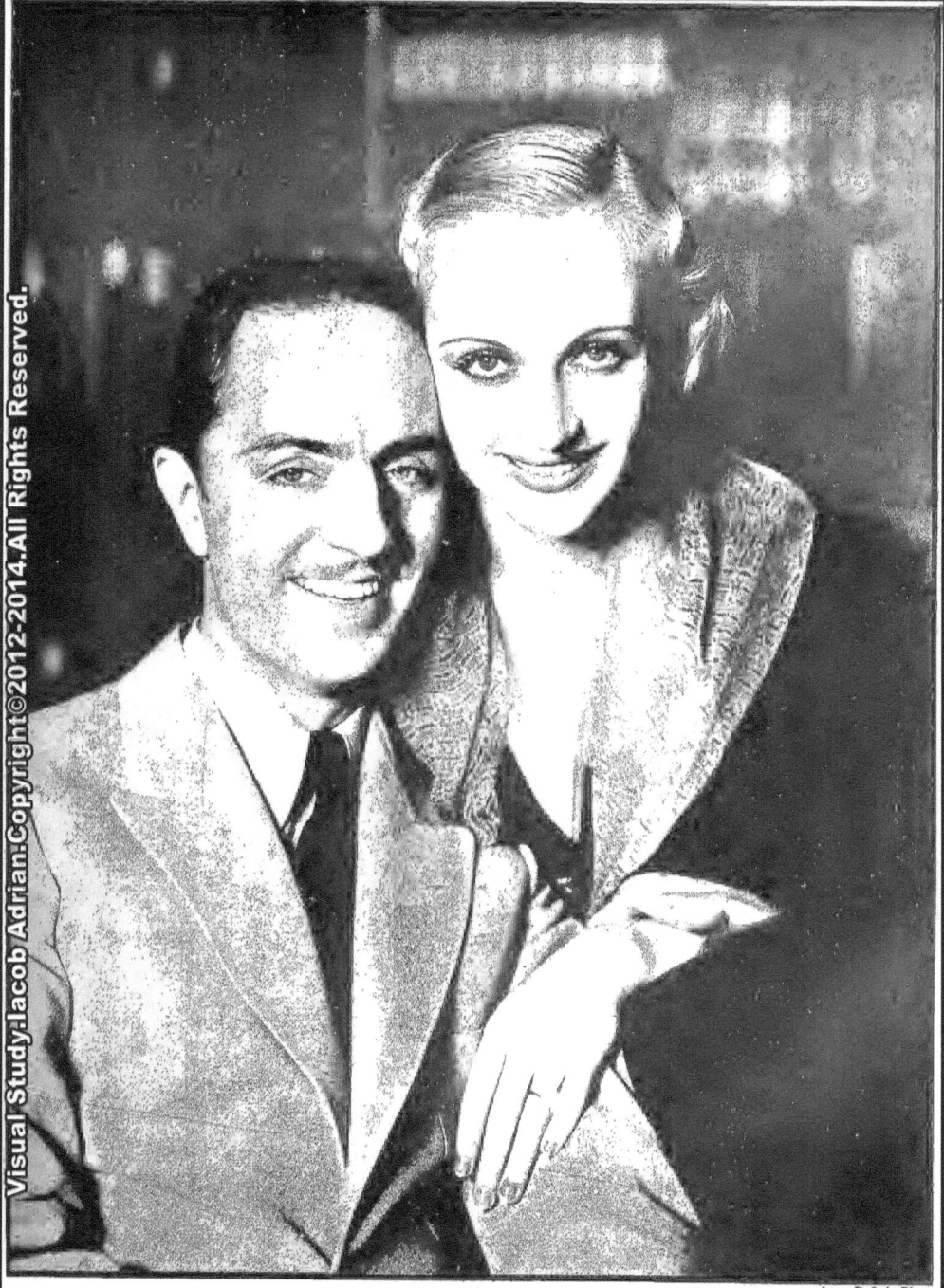

CAME THE WEDDING BELLS! Carole Lombard is now Mrs. William Powell. Hollywood had been looking forward to an elaborate Autumn wedding, but Mr. Powell and Miss Lombard surprised folks with a sudden and quiet ceremony, only relatives being present. Then they slipped away to Hawaii, the honeymooners' delight. Miss Lombard is not only one of the prettiest girls in the movie colony but she has been advancing rapidly—and Hollywood holds high promise for her. Mr. Powell is an able actor and a great fellow.

WARNER BROS. present

WILLIAM POWELL

as
The man men remembered
and women couldn't forget
in

The ROAD to SINGAPORE

DORIS KENYON
MARIAN MARSH

Based on a play by Roland Pertwee
from a story by Denise Robins

Directed by
ALFRED E. GREEN

A greater William Powell — more intriguing than ever before . . . See him as Warner Bros. present him: Suave gentleman! Debonair lover! . . . See him at the glamorous height of his dramatic power, in a story of tropic nights; of love under a languorous moon; and of a key given but not used . . . See him experiment with love in The Road to Singapore — the finest screen play of his career — a great Warner Bros. production worthy of William Powell's talents . . .

"Vitaphone" is the registered trademark of The Vitaphone Corporation

A WARNER BROS. & VITAPHONE PICTURE

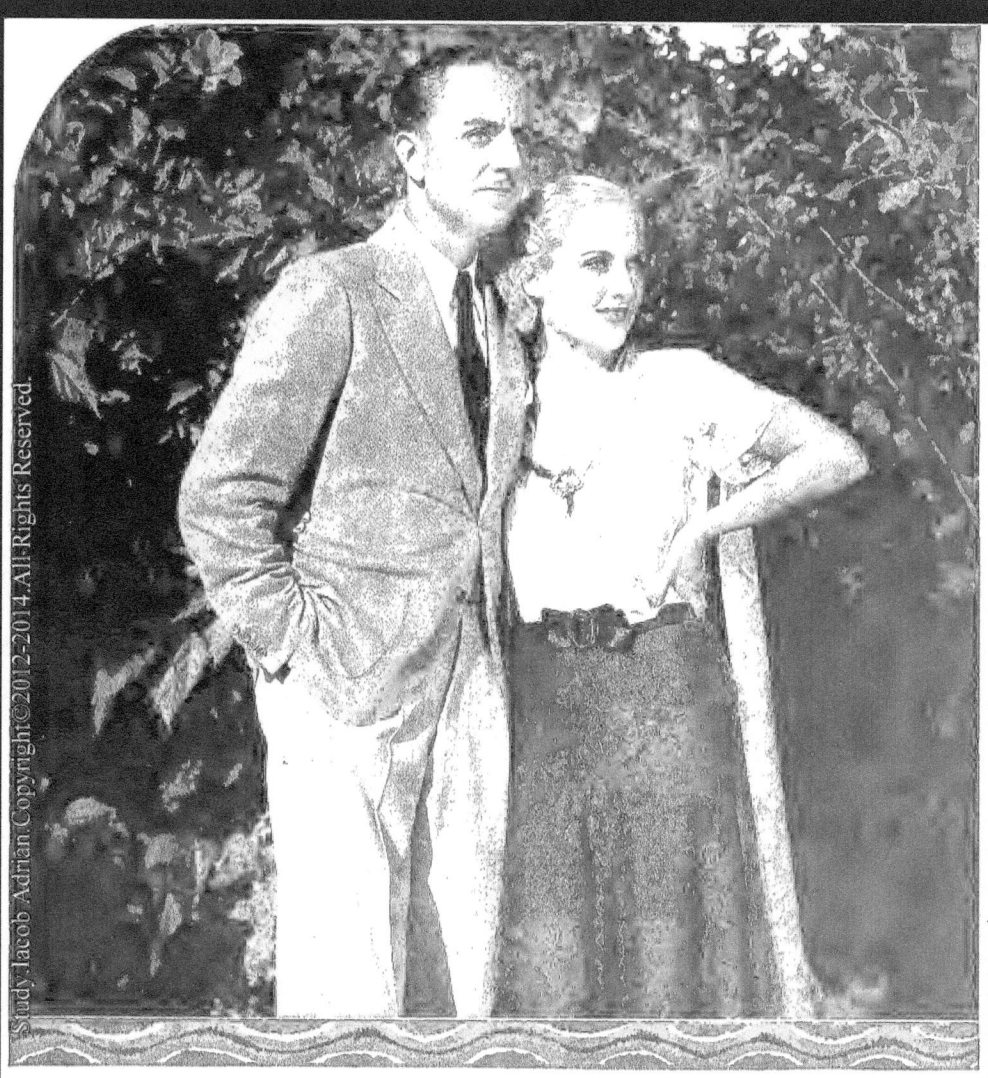

When the Stars Gaze at the Moon

WILLIAM POWELL AND CAROLE LOMBARD

One of the screen's newest honeymooning couples stand in their lovely Beverly Hills garden and look at the California love moon. We'll wager, too, that they are not thinking of the next picture each will make, but of the earliest time they will be able to get away from it all and take another trip to Honolulu. At present William is part of the loot that Warner Brothers won from Paramount, while Carole remains with the latter company.

JIM TULLY, the famous literary rebel, puts his microscope on the star who calls himself an—

Ugly MUG

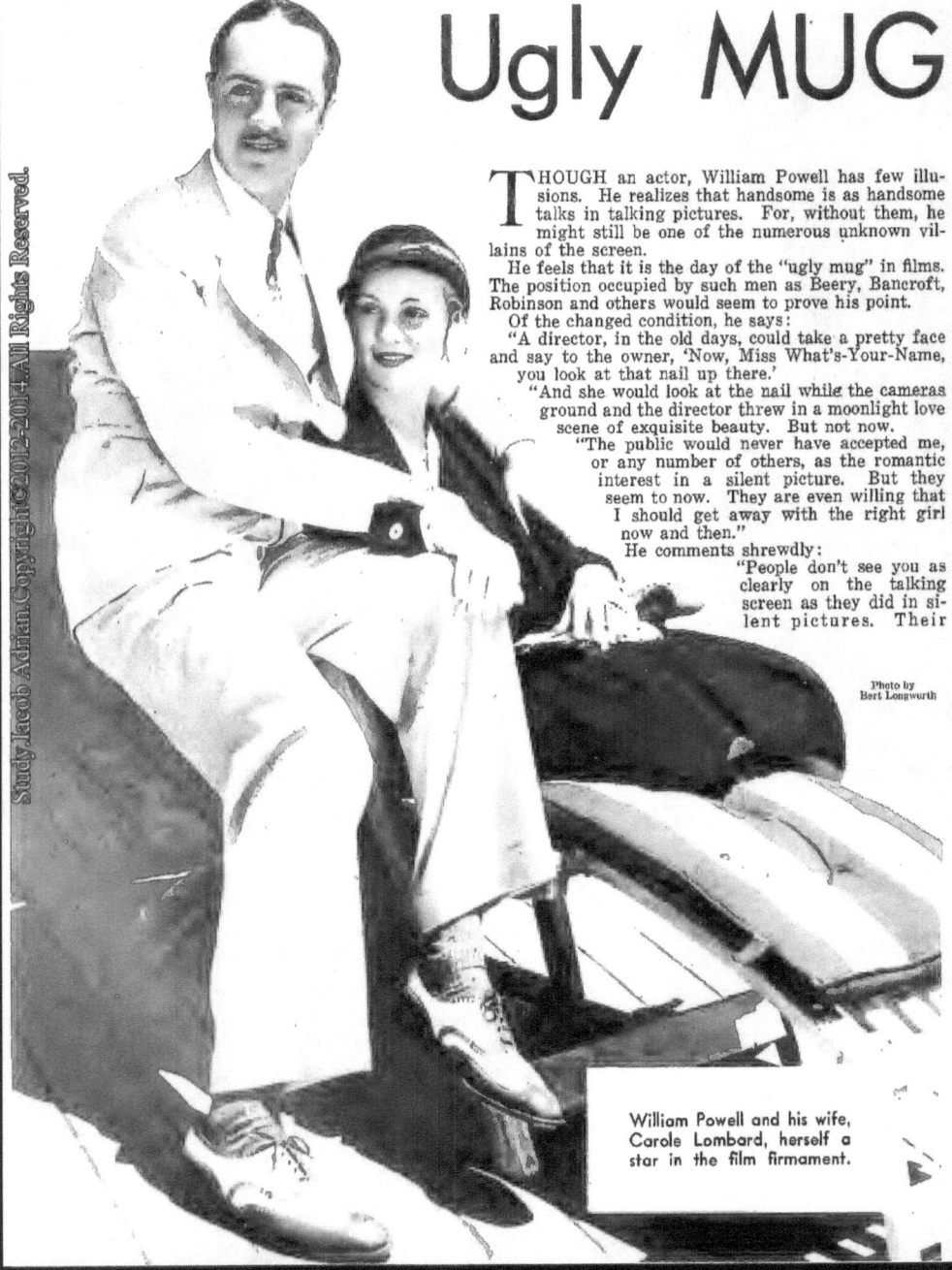

T HOUGH an actor, William Powell has few illusions. He realizes that handsome is as handsome talks in talking pictures. For, without them, he might still be one of the numerous unknown villains of the screen.

He feels that it is the day of the "ugly mug" in films. The position occupied by such men as Beery, Bancroft, Robinson and others would seem to prove his point.

Of the changed condition, he says:

"A director, in the old days, could take a pretty face and say to the owner, 'Now, Miss What's-Your-Name, you look at that nail up there.'

"And she would look at the nail while the cameras ground and the director threw in a moonlight love scene of exquisite beauty. But not now.

"The public would never have accepted me, or any number of others, as the romantic interest in a silent picture. But they seem to now. They are even willing that I should get away with the right girl now and then."

He comments shrewdly:

"People don't see you as clearly on the talking screen as they did in silent pictures. Their

Photo by Bert Longworth

William Powell and his wife, Carole Lombard, herself a star in the film firmament.

perception is divided between two senses. They are listening as well as watching, and neither sense is as sharp as the single sense of sight was in silent pictures. So some homely mugs get by.

"But for talking pictures I would probably still be a first-class villain in every silent picture in which I appeared. I was practically doomed by my face and my screen reputation to play the menace every time. I tried to make him a human menace, a character that was possible, not just a mechanical force to oppose the plot. But I couldn't have got away from the villain rôle if the screen had not learned to talk. But when the public heard my voice I had another chance."

IT will be seen that Powell has a proper appreciation of his position in the whirling cosmos.

His eyes are far apart and benign.

There is in them a touch of curiosity, as if he were seeing everything in the world for the first time. He is the kind of fellow whom you would like to accompany on a long journey. Far more sentimental than suave, though this is not generally known, he is more intelligent than most actors, and less egotistic.

He came out of the Middle West by way of Pittsburgh. His father, an accountant, was always in modest circumstances. There were even periods in which the family of three touched the edge of want. The elder Powell, a battered member of the White Collar Brigade, was worse off than the average laborer; he had, like so many in America, a position of pseudo-respectability to maintain.

Their son, an only child, was destined to go the average way. After declaiming well about something during high-school days in Kansas City, it was decided by the parents to have him enter the University of Kansas and study law. About this time Mr. Delmas made his speech to the jury that tried Harry K. Thaw,

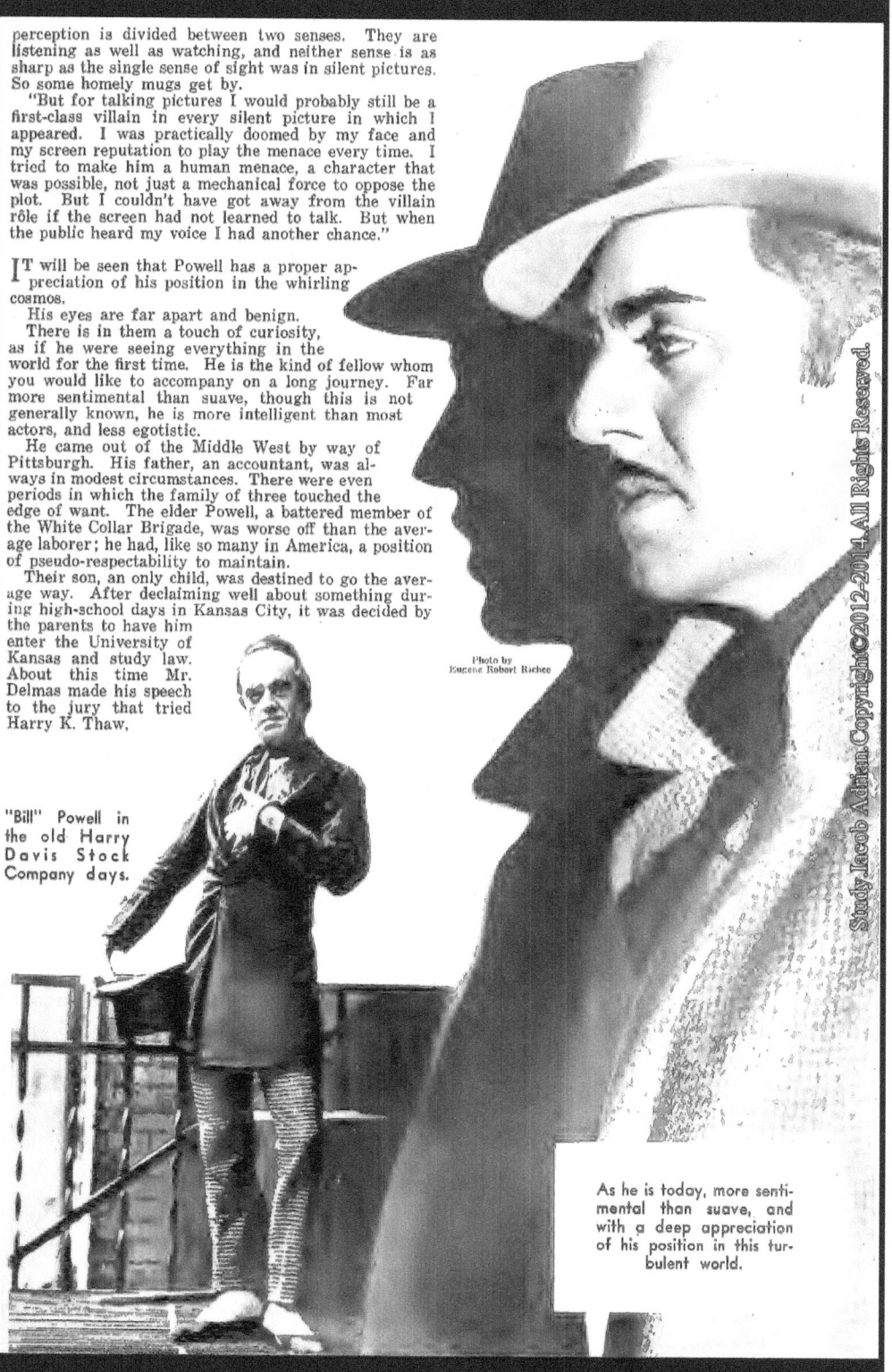

Photo by Eugene Robert Richee

"Bill" Powell in the old Harry Davis Stock Company days.

As he is today, more sentimental than suave, and with a deep appreciation of his position in this turbulent world.

Ugly Mug

in which he invented the term "brain storm" and inoculated the future actor with the virus of the law, the profession at which so many young men rightfully starve.

Then he was given a part in a high school production of "The Rivals." He received so much praise that he decided that there already were too many men in the so-called learned and oft-times shady profession of the law. He decided to be an actor.

He had heard, by this time, of the American Academy of Dramatic Art in New York. The tuition was four hundred a year. An additional amount would be required for his upkeep.

How would he obtain this sum?

His father, after a lifetime of accounting for the funds of others, had none for himself.

William, the accountant's son, readily accounted for his own predicament by deciding to go to work. He got a job with the telephone company in Kansas City at fifty dollars a month. By this time, as bad luck would have it, he had a sweetheart. It is difficult to entertain a girl in Kansas City without money. And William, even then, was ever gallant with the ladies.

He dreaded his work with the telephone company. Month followed month as months will, however, and he found himself unable to save any money toward the fulfillment of his cherished ambition.

NOW there comes into the tale an old woman riding the broom-stick of hate. She was William Powell's aunt, a woman of extreme intelligence. She had no earthly use for the accidental appendages known as relatives. She was also wealthy enough to be fortified against intimate association with them.

The young Powell knew all these things. But what has an aunt's attitude to do with a young man's ambition? He hugged his secret as if it were a leading lady. He would write to his aunt, who lived, secure from relatives, in a Pennsylvania town. He would tell her that he was a *different* relative. That he came not on an errand of hate—*but to borrow money*.

The days merged into weeks. He divided his spare time between ushering at the Grand Opera House, his sweetheart, and writing the letter to his aunt.

It was not a simple matter. The logic of Lincoln and the acumen of Disraeli would be needed to inveigle an old lady, immersed in generations of hate, into sending money to a young relative who wished to embark on so preposterous a journey.

The letter was finally finished. It was twenty-three pages long. It traced the sources of hate. It was tactful, pleading, and proud. No young man with such a burning desire to get on in the world should stand convicted of the hate caused by others. A silver, sentimental thread ran through the letter. In it the mood of Lincoln was invoked when he spoke of "the mystic chords of memory stretching from every hearthstone." Wondering, "What mystic chords of memory?" he nevertheless mailed the letter.

A month passed. No answer came. Chagrin, disappointment, humiliation followed on the heels of wounded pride.

"Oh, well," Powell said to himself, "I was like the fellow who died praying and woke up in Hades and said, 'Just as I expected.'"

He had told his aunt in the letter that seven hundred dollars would see him through a year at the Academy. He might as well have asked her for a million, he thought.

He had even offered to pay it back at any illegal rate of interest.

Another week passed. His work at a telephone company desk grew more monotonous and dreadful. He decided at last to get to New York in some manner and work his way through the Academy.

THEN one day, after weeds were high grown on the grave of hope, a letter came. It was postmarked from the town in Pennsylvania where his aunt lived with her hate.

She had long considered her nephew's letter. Paragraph followed paragraph in a cramped and ancient female hand. She thought the letter was well written, even intelligent. Her nephew's ambition, though dubious, was perhaps worthy. She had instructed her attorney to advance him seven hundred dollars.

One brought back to life from the gate of the grave could have been no more elated than was the young telephone clerk. He walked, in imagination, over the roofs of buildings.

The world was now his oyster, even though he had no knife with which to open it. That he was thirteen years in repaying the loan is mute evidence of the struggle through which he went.

He left the academy when his money was gone, and took a job—just what he does not say. It paid fifteen dollars a week and had nothing to do with the theater.

At this time another young fellow came on from Kansas City. He had done some drawing in high school and had come to the same conclusion as his young fellow townsman, that he would make a career in New York. He went far among the masters of his craft, and died a suicide pursuing the twin shadows of futility and beauty. His name was Ralph Barton.

The two young fellows rented a cheap room together. They walked the streets in destitution, looking for work.

They pawned their belongings until everything had seemingly disappeared. In the lowest depths of despair young Barton discovered a small air rifle and several boxes of tiny bullets. Simultaneously they started for the pawnbroker's. Then a thought came to them. They might as well shoot the cockroaches before the gun was sold. Before the sun went down more cockroaches died than in any one year in the history of New York.

The landlady rushed to the door, thinking that war had been declared. Whether in pity for the cockroaches, or irritated because the walls and floor of her room were perforated with bullets, history does not record. It does record, however, that a future cinema actor and famous illustrator were ejected from their room.

Disconsolate, they walked to the pawnbroker's with their cockroach exterminator. They were given a dollar and a half for the instrument. They existed on this sum for three days. Then a humorous weekly gave Barton thirty-three dollars for a drawing—and food again.

Powell was soon given work in "The Ne'er-Do-Well" at forty dollars a week. This was in 1912. He appeared in three different small roles in this play. It died early and Powell was soon destitute again. From the Fall of 1912 until the following Spring he was often hungry.

Then the clouds of misery parted. He was given a fairly important role in "Within the Law." The play ran two years. When it closed he "went into stock" and acted in plays in Pittsburgh, Boston, Detroit and Buffalo.

In 1920, after the closing of another play, he was seated disconsolate at a table in the Lambs Club. A director, name now unknown to fame, sat down beside him.

After glancing casually at Powell's profile for some time, the director asked, "How would you like to work in a picture?"

Powell's answer was, "When do we start?"

"Right away," said the director.

And thus the master detective of the screen made his bow to an indifferent world as a "heavy" opposite John Barrymore. The play was, ironically enough, "Sherlock Holmes." That the heavy was later to surpass Barrymore in the portrayal of such roles was not yet written in the faraway cinema sky.

B. P. Schulberg, the associate producer at Paramount, was the first to see big possibilities in the former telephone clerk. He brought him to Hollywood, where he became world famous.

POWELL has definitely studied his career. In "Sea Horses," with Florence Vidor, he changed from heavy to lover. The enormous fan mail indicated that he was popular in the latter role. In "Philo Vance" he reached another pinnacle of popularity.

No longer a featured player, he has since signed a two-year contract with Warner Brothers as a star. His salary is more than a thousand dollars a day.

His father and mother are with him in Hollywood. His sweetheart of the early Kansas City days is now married —to another man. She sends the suave ex-telephone clerk a Christmas card each year. And Powell, remembering, his wide-apart eyes tender, says, "She was a fine girl."

The aunt is long since, I hope, in heaven. She learned to love one relative. Proudly she watched her brilliant nephew become an honor to her name. To those who would say that all success is accidental, I might repeat that William Powell was thirteen years in repaying the seven hundred dollars to his aunt.

She gave him a receipt for the money and promptly expired.

"Did the shock kill her?" I asked.

"No—" he paused, "but it nearly did me." He said nothing for a moment, then slowly and distinctly, "She was a great woman."

We looked out of the window at a frayed gathering of extras.

"Why?" I finally asked.

The answer was; "She had faith."

I said no more.

Bibliographic sources :

Hollywood (1934-1943)
Publisher: Hollywood Magazine, inc. ; Fawcett Publications, inc.

The New Movie Magazine (1929-1935)
Publisher: Tower Magazines, inc.

This documentary study use,
combined in various proportions,
elements from the following categories,
forms and subsets :
- fair use
- documentary
- documentary photography
- feature
- journalism
- arts journalism
- visual journalism
- photojournalism
- celebrity photography
in order to :
- employ material as the object of cultural critique ,
- quote to illustrate an argument or point ,
- use material in historical sequence,
providing independent opinion,
using photos, press articles, advertisements,
opinions of fans etc. ...

Copyright©2012-2014 Iacob Adrian.All Rights Reserved.

Film Actors
Volume 16
William Powell
Documentary study

Part 1

ISBN-13 : 978-1512379419
ISBN-10 : 1512379417

Copyright©2012-2014 Iacob Adrian
All Rights Reserved.

Notice

This documentary study use historic, archived documents.

Because of this, some pages may look blurry or low quality.

Still are included in this book because they have

high value from critical, documentary, historical,

informative and journalistic point of view .

www.ingramcontent.com/pod-product-compliance
Lightning Source LLC
Chambersburg PA
CBHW021026180526
45163CB00005B/2142